A PHOTO GUIDE BY Kodak

The world's best-selling photography book

COLLINS

This revised edition first published in 1988

Reprinted in 1989

First published in 1982 by William Collins Sons & Co. Ltd. London • Glasgow • Johannesburg

Reprinted in 1984 (revised), 1985

Copyright © 1981, 1982, 1987 by Eastman Kodak Company

All rights reserved under International and Pan-American Copyright Conventions. No part of this publicaton may be reproduced, stored in a retrieval system, or transmitted in any form, or by any means, electronic, mechanical, photocopying, recording, or otherwise, without the prior written permission of the copyright owner.

ISBN 0 00 412259 3

Printed and bound in Japan

98765432

CONTRIBUTORS Eastman Kodak Company Martin L. Taylor, Author Donald S. Buck, Photography Neil Montanus, Photography Robert Brink, Production

Mark Hobson, Photography Tom Beelman, Photography William Paris, Photo Research and Art Direction Quarto Marketing Ltd., Design Roger Pring and Christopher Meehan, Designers Ken Diamond, Design Assistant

Contents

Introduction 6
The Ten Top Techniques for
Better Pictures
Operating Your Camera 16
Camera Handling 44
Film 48
People 50
Places
Travel 84
Pets 90
Zoos
Flowers and Plants
Buildings
Collectables and Objets d'Art 99
Action
Night
Bad Weather108
Showing Your Pictures112
Has It Happened to You?120
Simplifying the
Technicalities126
Camera Controls128
Film
Exposure
Depth of Field144
Lighting146
Flash
Existing Light162
Filters
Lenses
Close-Ups
Camera Care186
Photo Credits
Index

INTRODUCTION

Photography offers a twofold thrill to picturetakers. There's the delight in the event that you are planning to capture, and there's the pleasure in reviewing the pictures days, weeks, or even years later. With a little confidence in your knowledge, skill, and experience, you'll find that arranging or discovering a photogenic scene provides great satisfaction. Pictures are reminders, keys to the past—even bits of history, personal or documentary. They also express your moods, impressions, and feelings of the moment—visible statements of a very personal art.

How to Take Good Pictures will help you improve your pictures with any kind of camera. The advice on the following pages will familiarize you with many basic elements and techniques of photography. And as you become better acquainted with the principles of successful picture-taking, you'll feel more confident in your own results.

How to Take Good Pictures gives instruction with pictures, rather than with columns of number- and formula-laden text. In this step-by-step primer, words serve to emphasize or clarify the messages offered by the illustrations. The book begins with basic ideas for picture improvement and moves on to advanced concepts. Start with the Ten Top Techniques for Better Pictures on the next 8 pages. Then, either read on in sequence or turn to those sections that interest you the most.

Keeping a ready camera and searching for the best viewpoint can pay rich rewards, as in this view of Mont St. Michel. Notice how the peaceful grazing sheep help to establish distance relationships. Muted light from cloudy skies gives a special mood.

INTRODUCTION

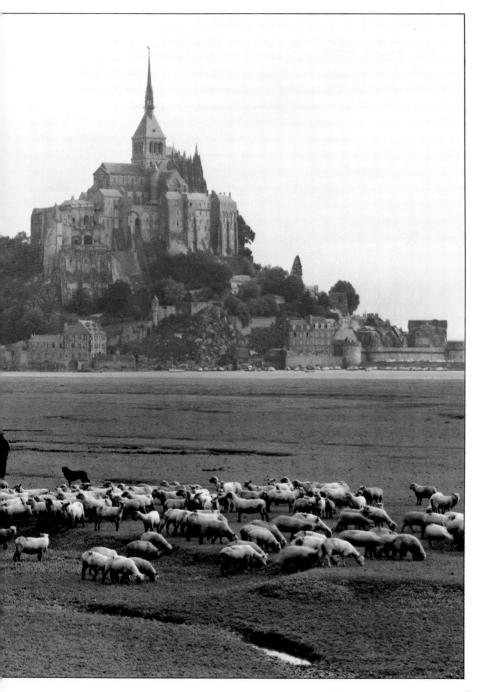

THE TEN TOP TECHNIQUES FOR BETTER PICTURES

(If you read no further, these ideas will give your picture-taking a dramatic improvement.)

1

Move close to your subject. Whether it is a village church, the Matterhorn, or a child with ice cream, get close enough so that you see only the most important elements in the viewfinder. Failure to observe this simple guideline accounts for more unsuccessful pictures than any other photo mistake.

Make sure that your automatic or manually adjustable camera is adjusted to give correct exposure. If your pictures are too light or too dark, check the camera manual and the film instructions. Remember to set the film speed—ISO—on most automatic cameras and sometimes the shutter speed or the aperture. On a manually operated camera, set the film speed, shutter speed, and aperture.

Correct exposure

Overexposed

Underexposed

3

Carefully observe both background and foreground in your viewfinder before you take the picture. Clutter or confusing elements tend to dilute the strength of your subject. Keep your pictures as simple as possible.

Cluttered background

Simple background

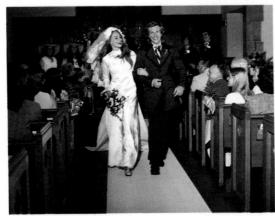

Correctly exposed flash pictures must be made within the flash-tosubject distance range for snapshot cameras. For automatic or manually adjustable cameras, the distance determines any adjustments to be made.

Flash is for dark places.

Steady camera, sharp pictures.

5

Hold your camera steady. Shaky hands or punching the shutterrelease button may give you blurred pictures. Brace the camera with both hands against your forehead and smoothly press the shutter release.

Shaky camera, blurred pictures.

6

Become thoroughly familiar with your camera. Read the instruction manual carefully so that you'll be comfortable making adjustments under a wide variety of conditions. As you read the manual, keep your camera in hand for reference.

Read your camera manual thoroughly.

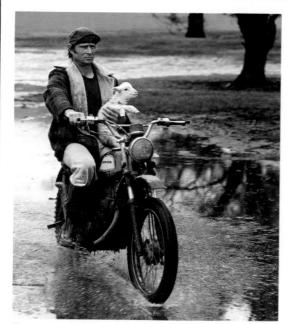

Try putting your subject off centre.

Set your subject slightly off-centre. When shown dead-centre in a picture, your subject may appear static and rather dull. Experiment to see where different subjects look best. Some cameras take square pictures and others take rectangular ones. If your camera takes rectangular pictures. you can get both horizontal and vertical pictures by holding the camera flat or on end.

Rather than posing people in a starchy, uncomfortable manner, engage them in a natural, absorbing activity to take their eyes off you and the camera. When people are doing something familiar, their bodies and faces will relax. The couple below was posed, of course, but the picture-taker found a way to draw their attention and commemorate a holiday at the same time.

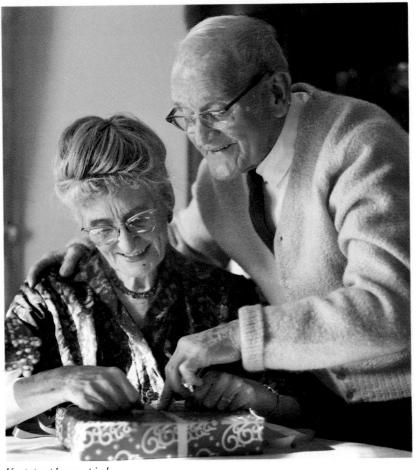

Keep people occupied.

Watch the direction of light in your scene. People tend to squint in bright, direct light and the dark shadows are often unattractive. Light from the side or from behind your subject may be more effective than light from the front. Picturetaking in the shade or on an overcast day may be better, too, if it is possible with your camera.

Frontlighting-light from the front

Backlighting-light from behind

Take plenty of pictures. Every professional knows that the potential for success rises with the number of pictures taken. Compared with some of the rare scenes you'll encounter, film is far less expensive than the prospect of a missed opportunity.

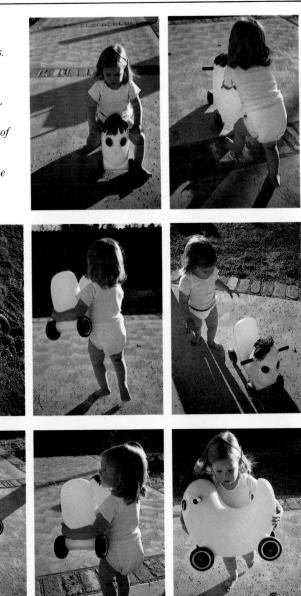

OPERATING YOUR CAMERA

TYPES OF CAMERAS

All cameras provide the same function—to allow a measured quantity of light to strike film. The light makes an image on the film and you get a picture. If you have an instant camera and film, you get a finished print from the camera. If you have a conventional camera that takes black-and-white, colour negative, or colour slide film, the film is usually processed by a photofinisher. You get slides or prints and negatives.

In this book, we'll discuss the use of several camera types: disc, cartridge-loading, and 35 mm. These cameras all work in basically the same way. Their layout may be slightly different, but the controls perform similar functions. In the next few pages, we'll provide a thumbnail sketch of each camera type, including its assets and its operating procedures. Since some cameras are more complex than others, we'll devote more space to them for greater clarity.

We'll be showing and describing some current cameras in this section. No matter what camera vou have, you'll want to refer to the instruction manual for specific information on loading and operating procedures. Kodak can furnish a replacement manual for a recent Kodak camera if your manual has disappeared. The same may be true with other manufacturers. Try your photo dealer if information for your camera is unavailable. Dealers are familiar with many cameras and should be happy to help.

KODAK VR 35 CAMERAS

KODAK VR 35 Cameras help you get great pictures by using a high-quality, all-glass lens and the latest technology to give you advanced features like automatic focusing and exposure control. The additional features of some models are a built-in automatic flash with a fill-flash feature; automatic film-speed setting; automatic film advance and rewind; and automatic exposure control. KODAK VR 35 Cameras can use 35 mm DX-encoded films with speeds of ISO 100, 200, 400. This means you can take pictures over a wide range of conditions and still get excellent results.

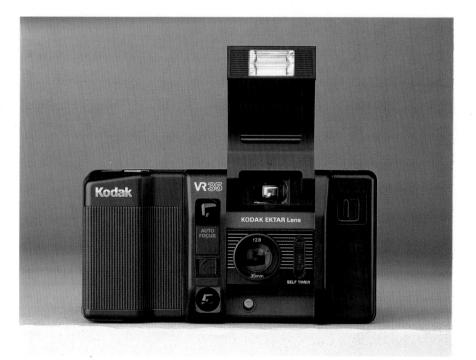

OPERATING KODAK VR 35 CAMERAS

All of the KODAK VR 35 Cameras use 35 mm film, so you can enjoy high-quality pictures. Automatic loading, advancing, and rewinding of the film means there is no fumbling in the middle of the action. KODAK VR 35 Cameras are some of the most advanced compact 35 mm cameras available today.

Slide down the back cover release to open the camera back.

Lay the leader across the back so that it lines up with the yellow stripe under the take-up spool, and make sure the sprocket teeth engage the perforations.

Load the film magazine into the film chamber so that the film leader points towards the take-up spool.

Close the back cover. Then lift the cover flash and press the shutter release. The film will automatically wind and stop when the frame counter reaches "1." (With some models, you must wind the film manually.)

OPERATING YOUR CAMERA

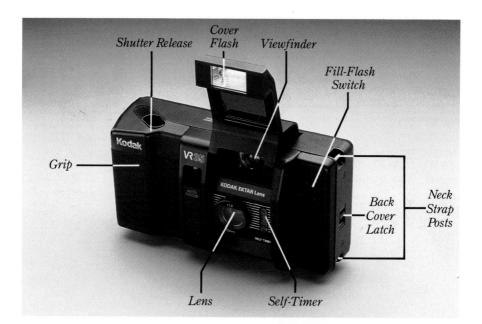

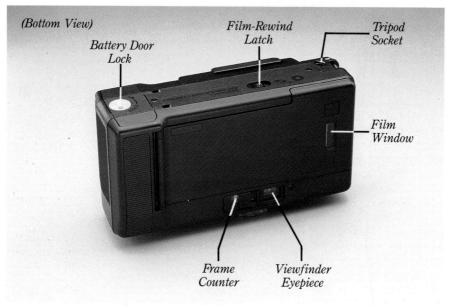

AUTOMATIC SETTING OF FILM-SPEED

All KODAK film magazines today are DX-encoded. The camera reads this code and sets the film speed automatically. With KODAK VR 35 Cameras, you can use film with ISO film speeds of 100, 200, 400, and 1000 (with some models). It's best to choose the appropriate film speed based on picture-taking conditions. When taking pictures under normal daylight conditions or indoors with flash, you may want to choose a film with ISO 100 or 200; for low light level conditions, you may want to use a film with ISO 400 or 1000.

AUTOMATIC FOCUS

Some KODAK VR 35 Cameras have fixed focus. But the more advanced models focus automatically. Look through the viewfinder and position your subject within the luminous frame. The area inside the luminous frame represents your picture. The autofocus frame marks in centre of the viewfinder indicate where you are aiming the camera's autofocus. When your subject is within the autofocus frame marks, take the picture. The camera will set the focus when you press the shutter release.

If you don't want your subject in the centre of the picture, use the prefocus control. Aim the camera so that the subject is within the autofocus frame marks. Then gently press the shutter release halfway to lock in the focus. As you continue to partially depress the shutter release, reframe the scene and then take the picture by fully depressing the shutter release.

OPERATING YOUR CAMERA

AUTOMATIC ELECTRONIC FLASH

When the light level is low, indoors or out, the flash on most VR 35 Cameras will fire automatically. The flash distance range is approximately 1.2 to 3.7 metres using ISO 100 film, 1.2 to 4.3 metres using ISO 200 film, and 1.2 to 4.8 metres using ISO 400 film. For extended flash range (between 2.4–5.5 metres), you can use ISO 1000 film.

A fill flash lever on some advanced models lets you use fill flash for backlit subjects, or to lighten shadows (especially on faces) in contrasty scenes. You simply slide in and hold the fill-flash lever while depressing the shutter release.

Use fill flash to prevent underexposure of the main subject. Left photo, the flash sensor was fooled by the bright background and was not triggered. Right photo, the fill flash allowed proper exposure of the girl.

USING THE SELF-TIMER

How many times have you reviewed your holiday pictures, only to find you do not have one picture of yourself to prove you were actually there?

If your camera has a self-timer, use it so you can get into the picture too. Simply place the camera on a tripod or other firm support. After composing the picture, slide the self-timer lever downward and press the shutter release. (Be sure not to stand in front of the picture-taking lens while pressing the shutter release.) You will notice the red LED selftimer indicator blinking. The picture will be taken in approximately ten seconds. Now, hurry into the scene! And don't bump the tripod or camera as you scramble to join your family.

REWINDING THE' FILM

After you take the last picture on the film, the film will automatically rewind with most VR 35 Cameras. The motor stops when the film is rewound fully. If you want to remove the film before the roll is complete, slide the film rewind latch in the direction of the arrow and the film will rewind. (Do not open the back door until after you rewind the film, or your film will be fogged.)

DISPLAY YOUR PICTURES

You'll be proud of the pictures you take with your KODAK VR 35 Camera. Show it by keeping your best results visible. Enlarge and frame your outstanding photos, or place them prominently in an album. Good storytelling snapshots should be the core of your album collection. And there are other ways to display your efforts that appear on pages 112-114.

Incidentally, some VR 35 models have a dateback feature that imprints the time or date on every picture. This feature offers an excellent basis for organizing your photos. It is also a great means for identifying the frame number when ordering reprints or enlargements for display from your local photofinisher.

Take good care of your pictures to make them last longer. Although you'll find ideas for safekeeping on page 115, please review these tips for proper treatment and handling of bictures taken with KODAK VR Cameras. Keep film (exposed and unexposed) out of hot and humid places. and out of direct sunlight; keep the processed negatives inside the photofinishing envelope for protection, or store them in specially designed negative storage sleeves available from your local photofinisher or camera store; and never touch the image area of the negatives—handle them only by the edges.

KODAK DISC CAMERAS

KODAK Disc Cameras and Film have a goanywhere, do-anything capability. A sensitive computer adjusts the exposure settings and provides flash when necessary. A built-in motor advances the high-speed film disc. And battery energy powers all camera functions. With its compact size and reasonable price, the KODAK Disc Camera can be your constant companion. Sophisticated engineering will allow you to capture almost any situation with aim-and-snap simplicity.

OPERATING DISC CAMERAS

Because KODAK Disc Cameras determine their own adjustments, you need only load the camera and snap the shutter. On some advanced models, you

1. When a disc shows "x" in the frame window, lift the disc door lever.

2. Swing open the disc door and remove the exposed disc film.

3. Unwrap a new disc film and insert it it fits only one way.

4. Close the disc door until seated then push the door lever down to lock.

can choose a close-up lens. Use the close-up lens selector for subjects in a 0.5-1.2 metre range. The normal position of the lens is marked with a 222, the close-up position with a 22.

MOTORIZED FILM ADVANCE

All KODAK Disc Cameras feature automatic film advance, powered by an electric motor. This motorized advance allows you to record more than a single glimpse of an activity. Keep your eye to the viewfinder to follow your subject and take a series of pictures that show a complete short story.

Document a chain of events with the automatic film advance of any KODAK Disc Camera.

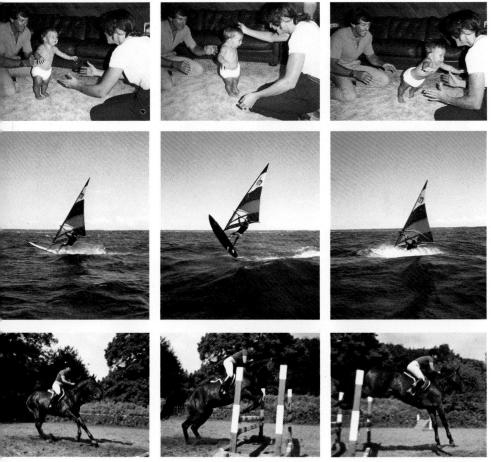

EXPOSURE FLEXIBILITY

KODAK Disc Cameras can take bright, well-exposed pictures in a wide variety of lighting conditions. Directed by an intelligently programmed computer, the camera's exposure controls will give you great photos in sunlight, gloomy overcast, bright interiors, and a host of other situations. And, if it's too dark, the flash will fire automatically to brighten your main subject. The result—a freedom to photograph almost anything you see.

In bright interiors, your KODAK Disc Camera will preserve the mood by taking excellent pictures with the natural light that exists in the scene, as the pictures above and at left illustrate. In darker conditions, as in all the pictures at right, the flash will assist to brighten nearby subjects.

Early in the morning, late in the evening, under stormy skies, in museums, or at brightly lit entertainment, your KODAK Disc Camera will capture more scenes than you ever thought possible.

AUTOMATIC ELECTRONIC FLASH

In dark conditions the computer in a KODAK Disc Camera fires the flash when you press the shutter release. You won't have to wait long, either—the recycle time is very short. The brief intensity of electronic flash will stop action. The range of good exposure is extraordinary, and there are many possibilities for using the flash when the ambient light is adequate but dull. Dim interiors, deep shade outdoors, and backlighted subjects early or late in the day are typical situations when your flash will make a bright picture in a drab situation. At top left the always alert flash of a KODAK Disc Camera captures a typical indoor scene automatically. The centre and right photos illustrate how the flash and the low-light capability complement each other by giving brightly lit foreground subjects against still-visible interesting backgrounds.

Notice at right how the flash illuminated the girls in the dark foreground to provide an attractive lighting balance with the bright doorway.

CLOSE-UPS

Every KODAK Disc Camera will take sharp pictures in a broad range of distance—from 1.2 metres to infinity. But for small subjects the KODAK Disc 6100 Camera offers an auxiliary close-up lens that will help you get big images at close distances. By sliding the close-up lens lever into position, you can move as close as 46 centimetres or as far as 1.2 metres. The KODAK Tele Disc Camera has a telephoto lens for subjects beyond 1.8 metres. With the telephoto lens, subjects will appear closer than they do with the normal lens.

CARTRIDGE-LOADING CAMERAS

Cartridge-loading cameras are among the simplest to operate of all conventional film cameras. Loading is easy, and there are few if any adjustments to be made.

Advantages Cartridge-loading cameras—particularly the 110 size—are small and lightweight so that they're easy to pack around. Although you have to send the film to be processed, you will have a great variety of processing services available. Print quality is superb in most situations and the cost of the camera is usually fairly low.

The small, 110-size cartridge fits in pocket cameras. The larger 126 cartridge fits in the familiar KODAK INSTAMATIC[®] cameras.

The simplest of all cartridge-loading cameras give the greatest ease of operation. There is nothing to do except load the film and snap a picture. You can take pictures on sunny days or hazy days outdoors, or use flash for nearby subjects when the light is dim.

More advanced models, which naturally cost more, may adapt to a wider range of lighting conditions. Not only can you take pictures in bright conditions, you can also take pictures under heavy overcast or in the shade. Some cameras even allow you to take pictures without flash in the typical light of your home.

Operation Picture-taking with a cartridge-loading camera is easy and fun. Loading is usually the first step. Let's take a look.

Loading

Insert the new cartridge—it fits only one way. Close the film-compartment door and lock the latch, if necessary.

Unloading

When you see an empty cartridge in the window of a 110 or 126 camera, it's time to unload.

Operate the film advance until it will go no farther.

Open the film-compartment door by sliding or depressing the latch and swing the door open.

Number "1" will appear in the window—you're ready to take pictures.

Drop the cartridge into your hand.

35 mm CAMERAS

There are dozens of 35 mm cameras on the market today. They range from simple, autofocus cameras to advanced single-lens-reflex (SLR) models with interchangeable lenses. The model you choose will depend largely upon your budget, and how involved you want to be in the picture-taking process. Many people start with a smaller, less expensive camera and then, as their techniques become more advanced, they progress to a model that offers more options. Others choose to stay with an easier-to-use compact camera because of its convenience.

Non-Reflex Cameras

Compact autofocus and rangefinder cameras usually cost less than SLR cameras, but still yield excellent results. KODAK VR 35 Cameras are some of the best buys on the market today. They come in a variety of models and prices, and make your picture-taking virtually decision-free. Features such as autofocus, autoflash, and automatic advance and rewind, let you obtain good quality 35 mm pictures with just a push of a button.

There are many non-reflex cameras on the market today, including KODAK VR 35 Cameras.

Single-Lens-Reflex Cameras

Fully automatic, single-lens-reflex (SLR) 35 mm cameras are becoming very popular with today's photographers. DX-encoded films have made automatic film-speed setting possible. Automatic advance and rewind, autofocus on some models, and automatic exposure make these cameras almost as easy to use as the more compact cameras. However, you have some additional choices such as a variety of interchangeable lenses, and optional exposure modes. You can choose an exposure mode (which sets the shutter speed and aperture) based upon the type of subject matter you are photographing and the type of results you want. The modes include manual, programme, shutterspeed-preferred, and aperture-preferred. A camera that offers several of these exposures is known as a multi-mode camera. We explain these modes in more detail below. And, of course, SLR means that the camera takes the picture through the same lens that you view the scene (unlike non-reflex cameras), and that means you get exactly what you see.

If you buy a multi-mode SLR camera and a few lenses, you will have to make decisions during picture-taking. You'll need to know when to choose one lens or one setting over another. You may not understand fully at first, but you can learn as you go along and as you gain experience. These options allow you to get better results over a broader range of picture-taking conditions, and allow you to be more creative. They turn simple snapshooting moments into fun-filled photography experiences. *Programme Exposure* If your camera has one or several programme modes, that means it can set both the shutter speed and the aperture after metering the scene. Some cameras have only a "normal" programme mode that does not give a preference to either aperture or shutter speed. Other cameras have additional programmes designed for photographing action or scenes requiring great depth of field. The programme for photographing action is typically called an action programme. The programme for great depth of field is often called a depth programme.

If you are photographing your son heading a soccer ball into the goal, set the camera on the action programme. It favours a fast shutter speed and a moderate-to-large aperture; a typical setting might be 1/500 second. f/4. But, if you are photographing a field of daisies leading up to a barn, vou'll need great depth of field-not a fast shutter speed. So, set your camera to the depth programme. It favours a small aperture, and a moderate shutter speed: a typical setting might be 1/60 second. f/11. Since the automatic camera settings depend partly on available light, always check the settings to be sure they meet your needs. And if you are doing just general photography, set your camera for the normal programme: a typical setting might be 1/125 second, f/8.

Semi-automatic Modes

Shutter-Speed-Preferred If your camera has a shutter-speed-preferred mode, you choose the shutter speed and the camera chooses the aperture. Some cameras with programme exposure also have semi-automatic modes. However, many cameras on the market offer only semi-automatic and manual modes, without programme exposure. These cameras are considered "semi-automatic."

The difference between this mode and programme mode is that, with shutter-speedpreferred, you select the shutter speed and it stays constant (until you choose to change it). If you focus on a new scene, the old shutter speed is still in effect. You would need to rethink your needs, and change the shutter speed manually if necessary.

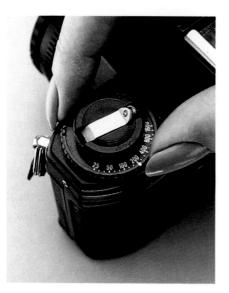

Aperture-Preferred If your camera has an aperture-preferred mode, you choose the aperture and the camera chooses the shutter speed. In dim light, keep in mind that you would usually want to select a larger aperture. Otherwise, the camera may set a slow shutter speed that would require use of a tripod. (The larger the aperture, the smaller the f-stop.) In brightly lit scenes, use a small aperture.

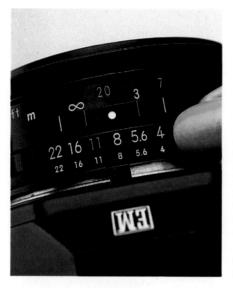

An aperture-preferred automatic camera requires that you set the aperture; the camera sets the shutter speed for the lighting conditions. First, make sure that the correct film speed is set on the camera. Then, set the aperture. A good aperture for general picture-taking is f/8.

Manual Cameras

Although several automatic cameras have a manual mode, only a few cameras on the market today are solely manual. With manual cameras, you have to set both the shutter speed and the aperture. The majority of manual cameras have built-in exposure meters that help you make appropriate settings for the lighting conditions and for the film you're using. Even if your camera does not offer manual exposure, it's helpful to understand the reasons for choosing particular apertures or shutter speeds. This information can be valuable when deciding which mode to choose on automatic cameras.

Many cameras give you exposure information in the viewfinder. You may see the shutter speed and the aperture settings, and sometimes a bracket with a needle that points to + or - for over or underexposure. Older cameras may have a bracket with a needle on the outside of the camera. Some of the latest cameras have a liquid crystal display atop the camera, that gives exposure information.

Some older manual cameras do not have a builtin meter, and you must use a handheld meter to determine your camera settings. Also, unlike the newer cameras with the autofocus feature, you must focus the camera to take a picture. Since focusing varies from camera to camera, it's best to consult your instruction manual for more details. In addition, with manual cameras, you must set the film-speed dial manually for the speed of the film you are using.

Operation Operating a 35 mm camera requires a bit of understanding for best results. We'll give enough basic information in this section to get you started with your 35 mm camera. For a better understanding of how photography works, and how such information applies to you and your 35 mm camera, turn to page 126. That section of the book will clarify questions about settings. There's also information on flash, filters, and other subjects that will help you to take better pictures in a variety of situations.

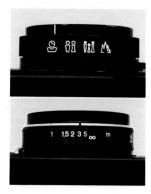

	Light Conditions				
Film Speed ISO	Bright or Hazy Sun on Light Sand or Snow	Bright or Hazy Sun (Distinct Shadows)	Weak Hazy Sun (Soft Shadows)	Cloudy Bright (No Shadows)	Open Shade or Heavy Overcast
25-32	1/125, f/11 1/60, f/16 1/30, f/22 1/250, f/8 1/500, f/5.6 1/1000, f/4	1/125, <i>f</i> /8 1/60, <i>f</i> /11 1/30, <i>f</i> /16 1/250, <i>f</i> /5.6 1/500, <i>f</i> /4 1/1000, <i>f</i> /2.8	1/125, f/5.6 1/60, f/8 1/30, f/11 1/250, f/4 1/500, f/2.8 1/1000, f/2	1/125, <i>f</i> /4 1/60, <i>f</i> /5.6 1/30, <i>f</i> /8 1/250, <i>f</i> /2.8 1/500, <i>f</i> /2 1/1000, <i>f</i> /1.4	1/60, f/4 1/30, f/5.6 1/125, f/2.8 1/250, f/2 1/500, f/1.4
64 100*- colour negative	1/125, f/16 1/60, f/22 1/250, f/11 1/500, f/8 1/1000, f/5.6	1/125, <i>f</i> /11 1/60, <i>f</i> /16 1/30, <i>f</i> /22 1/250, <i>f</i> /8 1/500, <i>f</i> /5.6 1/1000, <i>f</i> /4	1/125, f/8 1/60, f/11 1/30, f/16 1/250, f/5.6 1/500, f/4 1/1000, f/2.8	1/125, f/5.6 1/60, f/8 1/30, f/11 1/250, f/4 1/500, f/2.8 1/1000, f/2	1/125, f/4 1/60, f/5.6 1/30, f/8 1/250, f/2.8 1/500, f/2 1/1000, f/1.4
125 200*- colour negative	1/250, f/16 1/125, f/22 1/500, f/11 1/1000, f/8	1/250, f/11 1/60, f/22 1/125, f/16 1/500, f/8 1/1000, f/5.6	1/125, f/11 1/60, f/16 1/30, f/22 1/250, f/8 1/500, f/5.6 1/1000, f/4	1/125, <i>f</i> /8 1/60, <i>f</i> /11 1/30, <i>f</i> /16 1/250, <i>f</i> /5.6 1/500, <i>f</i> /4 1/1000, <i>f</i> /2.8	1/125, f/5.6 1/60, f/8 1/30, f/11 1/250, f/4 1/500, f/2.8 1/1000, f/2
200 400*- colour negative	1/500, f/16 1/250, f/22 1/1000, f/11	1/500, f/11 1/125, f/22 1/250, f/16 1/1000, f/8	1/250, f/11 1/125, f/16 1/60, f/22 1/500, f/8 1/1000, f/5.6	1/250, f/8 1/125, f/11 1/60, f/16 1/30, f/22 1/500, f/5.6 1/1000, f/4	1/250, f/5.6 1/125, f/8 1/60, f/11 1/30, f/16 1/500, f/4 1/1000, f/2.8
400	1/1000, f/16 1/500, f/22	1/500 , <i>f</i> /16 1/250, <i>f</i> /22 1/1000, <i>f</i> /11	1/500, f/11 1/250, f/16 1/125, f/22 1/1000, f/8	1/500, <i>f</i> /8 1/250, <i>f</i> /11 1/125, <i>f</i> /16 1/60, <i>f</i> /22 1/1000, <i>f</i> /5.6	1/500, f/5.6 1/250, f/8 1/125, f/11 1/60, f/16 1/30, f/22 1/1000, f/4
1000- colour negative	1/1000, <i>f</i> /22	1/1000, f/16 1/500, f/22	1/1000, <i>f</i> /11 1/500, <i>f</i> /16 1/250, <i>f</i> /22	1/1000 , <i>f</i> / 8 1/500, <i>f</i> /11 1/250, <i>f</i> /16 1/125, <i>f</i> /22	1/1000, f/5.6 1/500, f/8 1/250, f/11 1/125, f/16 1/60, f/22

Outdoor Daylight Exposure Settings for a Manual Camera

Note: Shutter speeds are in seconds. Exposure settings in heavy type indicate suggested settings for general use.

*Since these colour negative films tolerate moderate overexposure, the values in the table above are designed for maximum exposure latitude. Slide films, however, must be exposed accurately.

Loading 35 mm Cameras

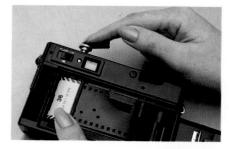

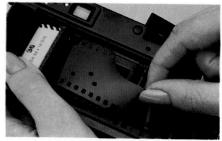

Insert a film magazine into the film compartment. The edge of the leader strip with the sprocket holes should be at the bottom. Press the rewind lever down to lock the magazine in position. Hook a sprocket hole into the film take-up spool. Advance the film until both sets of sprocket holes are riding on the sprockets. See your manual if your camera has automatic film loading.

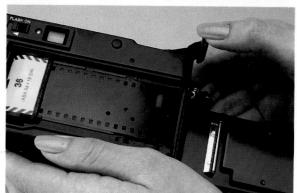

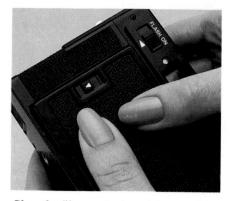

Close the film-compartment door so that it snaps shut.

Advance the film and snap the shutter several times until the number "1" shows in the film-counting window.

Unloading 35 mm Cameras

If your camera has made the last exposure on a magazine of film, depress the film-advance release button on the bottom of the camera.

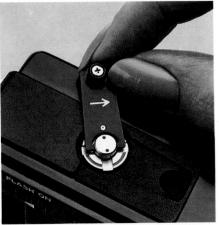

Pull out the rewind lever, and turn it in the direction indicated until you feel no more resistance, or activate the rewind switch if your camera has motorized rewind.

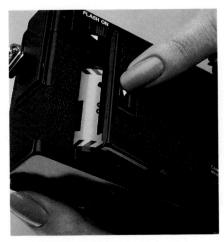

Open the film-compartment door by sliding a latch on the back or side of the camera or by pulling up the rewind lever.

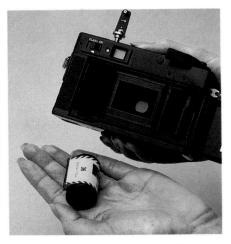

Remove the film magazine by pulling up the rewind lever, if necessary, and dropping the magazine in your hand.

Flash

Electronic flash is the most common source of portable light with 35 mm cameras. It is convenient and compact and provides a way for you to take pictures when there isn't enough light.

Many compact, autofocus cameras have a small electronic flash unit built into the camera. To take a flash picture you extend the flash unit and turn it on. On some models, it automatically fires when needed. When the ready light glows, you take a picture. You must wait for the ready light to glow again before taking the next picture. Occasionally, you will have to replace the separate batteries that power the flash. You can tell that the batteries are ready for retirement when the ready light takes longer to glow than the instruction manual recommends. Although focusing the camera on your subject sets the camera for flash exposure, check the manual for the flash range that will give you good pictures.

Most KODAK Disc and VR 35 Cameras have a built-in flash that works automatically. The camera automatically senses the amount of light and fires the flash when needed. There is no decision making for you.

Many nonreflex cameras have a built-in electronic flash unit. Slide or depress a switch to turn it on. When the ready light glows, you're ready to take a picture.

Other rangefinder and reflex cameras are equipped so that you can attach an auxiliary flash unit. A shoe on the top of the camera will accept the foot of most flash units. The first step is to insert the flash unit into the shoe. If the accessory shoe and flash foot are "hot" (check the camera instruction manual), all the necessary electrical connections have been made by inserting the flash unit. If the flash shoe or foot isn't hot, you make the electrical connection with a small cord (the PC cord) usually supplied with the flash unit. Plug the cord into the flash and into the correct socket on the camera and you're in business. Set the camera shutter speed as recommended by the camera instruction manual for correct shutter synchronization. A typical synchronization setting for electronic flash would be 1/60 or 1/125 second.

Newer SLR cameras usually have an electrically wired accessory shoe on top of the camera. When you slide a similarly wired flash unit into the shoe, all the electrical connections are established. Older cameras or older flash units may require the use of a small cord that comes with the flash unit to make the connection.

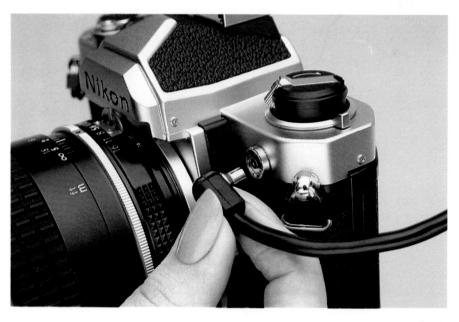

Flash Exposure

Setting the aperture depends on the flash-to-subject distance. Generally, there are three systems for choosing the aperture, which we'll discuss in more detail in the "Flash" section of the book, page 152—self-quenching automatic, dedicated, and manual. Self-quenching automatic means that the flash unit has a sensor that shuts off the flash when enough light has reached the subject. First, you set the film speed on the flash unit. Then choose an aperture/distance-range mode and set the recommended aperture on the camera for that mode. To take a picture, you focus, make sure that the subject is in the distance range for that flash mode, and snap the shutter.

Automatic flash units require that you set the film speed on the calculator on the back of the flash unit. Then choose an automatic flash mode for the distances you'll be photographing. Here we chose the yellow mode. Set the aperture - f/8 in this case-recommended by the flash unit. Make sure that the distance between flash and subject falls within the automatic flash range-1.6 to 8.5 feet in this case.

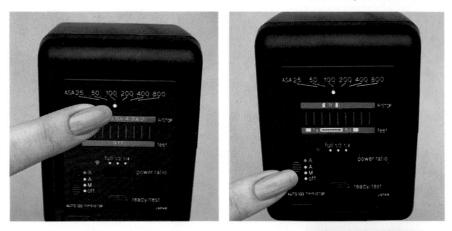

Dedicated flash systems differ, but the idea is generally the same. A sensor in the camera (not on the flash) determines when enough light has reached the film, and then shuts off the power in the flash unit. Since these systems vary, you'll want to pay careful attention to the instructions. Some rangefinder cameras allow you to set the guide number of the flash (a number found in the flash instruction manual that describes the power of the unit with a specific film) on the camera. When you set the camera to a flash mode, you select the aperture by focusing the camera.

A dedicated flash and camera system will establish all connections when the flash is attached.

OPERATING YOUR CAMERA

Manual flash is easier to talk about but takes a few more steps to perform. When the flash is all connected to the camera, you set the film speed on the flash calculator, and focus on the subject. Refer to the distance scale on the lens barrel for the camera-to-subject distance. Then apply that distance to the flash calculator. The aperture number will appear opposite the distance. Set the lens aperture and take a picture.

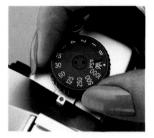

Set the recommended flash shutter speed on the camera. Then set the film speed on the flash calculator dial. Focus on your subject. The flash-to-subject distance will appear on the lens distance scale. Apply that distance to the flash calculator. Here it is 3 metres. The recommended aperture setting, here, between f/5.6 and f/8, will appear opposite the flash-to-subject distance. Set the recommended aperture on the lens-aperture ring.

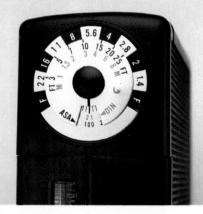

Electronic flash units work on either rechargeable batteries or disposable batteries. When the recycle times get longer than recommended by the flash manual, replace or recharge the batteries. For more important flash battery information, refer to page 157.

Note: If the film-speed dial won't register the 1000-speed film you're using, set it to 500 and select a lens opening one stop smaller than indicated.

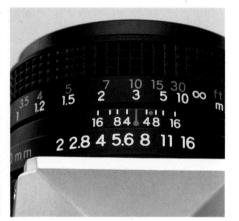

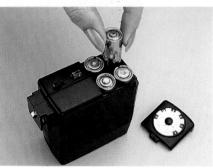

CAMERA HANDLING

Proper camera handling may be one of the most important contributions to good pictures. We have a number of tips to help you improve the way you take pictures.

Holding the Camera Steady

Start taking sharp pictures by holding the camera steady. Stand comfortably balanced with your legs slightly apart. Grip the camera, one hand on each side, and gently press your elbows into your side. If you've been exerting yourself—walking up a hill, for example—let your breathing resume a slow, steady pace before taking a picture.

Pressing the Shutter Release

Slowly press the shutter-release button until the camera takes a picture. This will give you a better chance at sharp pictures and help you maintain good composition.

Keeping the Lens Clear

One common problem is arranging a beautiful scene in the viewfinder only to discover later that a finger, the camera strap, part of the camera case, or even the lens cap covered the lens while you took a picture. Make it a practice to clear the lens area of obstructions before taking the picture.

Focusing

There are three typical focusing operations. The simplest is choosing one of several symbols on the distance scale on the lens that corresponds to the approximate distance between you and your subject. Or, you set the camerato-subject distance in feet or metres.

Some cameras have a rangefinder coupled to the lens. To focus, you turn the lens focusing ring until the two images in the centre of the viewfinder coincide. You can also set the calculated distance in feet or metres on the lens distance scale.

Many SLRs and compact cameras on the market today have an autofocus feature. You need first to centre the main subject so the autofocus system can focus on it. If you don't want the subject centred in the final results, you can lock in the focus with the subject centred and then reframe the scene.

In a manually-focused single-lensreflex camera you can see when the lens is focused because you see the same image the lens sees. There are a number of aids to help you, usually found in the centre portion of the viewfinder.

Using the Viewfinder

In some camera viewfinders, the picture area is defined by a bright rectangle or square. Other camera viewfinders use the entire viewfinder. Check your instruction manual to get the important elements of the scene into your picture.

When you see foreground litter or a confusing background in the viewfinder, choose another position. Horizons should be level.

Camera Support

Many automatic and adjustable cameras will operate at shutter speeds slower than 1/30 second. At these slow speeds, even your steadiest position. grib. and release may jiggle the camera and result in blurred pictures. Lean against a tree or wall or rest the camera on a table or rock. A tribod will give the most reliable steady support. A cable release will remove your shaky hands from the camera.

CAMERA HANDLING

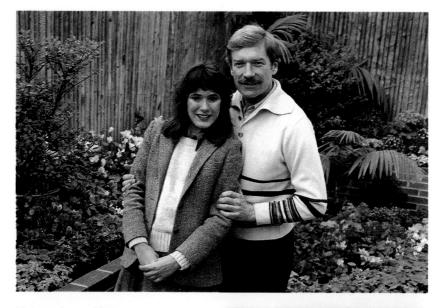

Using the Self-Timer

The self-timer is handy when you want to include yourself in the picture. Set the timer, press the shutter release, and position yourself in the picture. You'll have between 8 and 12 seconds to get there. When you're arranging the picture in the viewfinder, leave room for yourself. Place your camera on a solid support such as a table, fence post, rock, or tripod.

FILM

Film is available in different sizes for different cameras. Check your camera instruction manual for the correct size film. And, choose film for the kind of pictures you want—colour prints, colour slides, or black-and-white prints.

Films are also available for some cameras with different sensitivities to light. "Fast" films are very sensitive. You might use them in dim light. There are also slower films that are good for very sharp pictures in bright light. You'll probably want to use a medium-speed film for most picturetaking.

The speed or sensitivity is identified by ISO numbers. A medium-speed film might have an ISO rating of 64 to 200. High-speed film would be 250 to 640; very high-speed film 800-1250, and a low-speed film 50 or less.

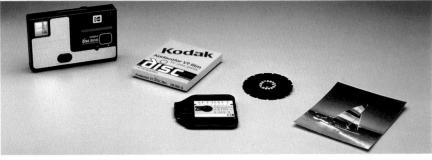

camera disc film box enclosure negative

print

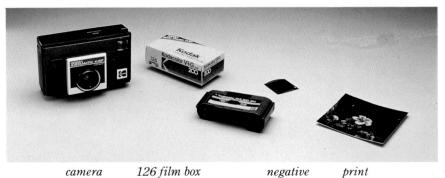

cartridge

Most films are manufactured to give pictures in daylight. Others, however, are designed to give pictures with correct colour appearance when used with artificial light sources—household bulbs (tungsten) or photographic lights. See pages 134 and 168-169 for more information about these films.

There is an expiration date on most film packaging. Film, like food, can go bad from ageing and may yield pictures of inferior quality. Check the date when you buy new film, and don't forget the film in your camera. Take the pictures and get them processed quickly. Film doesn't like extreme heat or humidity, either. Keep it out of direct sunlight and other hotspots.

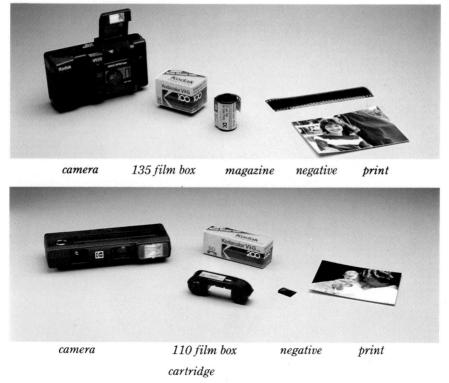

PEOPLE

When you photograph people-friends and family or interesting strangers-you want them to look their best. Portray them naturally. Show some of the unique traits that distinguish them from the rest of the crowd. Spend a moment considering what important characteristics identify the people close to you. It might be helpful to suggest expressions, clothing, props, and activities that will encourage the real people to emerge from behind the masks they usually put on for the camera.

Direction of light

Frontlighting

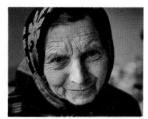

Sidelighting

Backlighting

OUTDOORS

Light—its direction and intensity—is all-important in your outdoor portraits. Direct sunlight can illuminate a subject from one of three directions. *Frontlighting* is harsh, usually causing a person to squint, and often making heavy shadows on the person's face. *Sidelighting*, where half of the face is in shadow, can be effective for a dramatic portrayal. *Backlighting* will give a silhouette when the camera is adjusted for a sunlight exposure; it can give a gentle appearance, however, when the camera is adjusted to record the subject's most important features. (Backlighting can fool an automatic camera. See page 142.)

There are two ways to cope with direct, bright sunlight from any direction. One way is to place a piece of white cardboard in a position to reflect some light into the shadow areas. Almost anything in a light, neutral tone will do-bedsheets, a newspaper, towels, a white wall, or even a footpath.

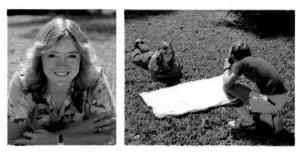

Fill-in Flash

Fill-in flash can brighten dark shadows in outdoor pictures. A camera that has built-in flash or that takes disposable flash devices provides easy flash fill. Position your subject near the maximum distance recommended by the camera manual and take a flash picture.

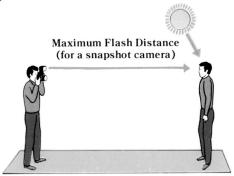

Using Flash in Daylight

Some KODAK VR 35 Cameras have a fillflash feature. This can be used when the main subject has less light falling on it than the surrounding area. Without fill flash, the main subject would be underexposed. (This is because the automatic flash sensor is being fooled by the bright surroundings and is not triggered.) By sliding in and holding the fill-flash switch during picture-taking, you can overcome underexposure of the main subject.

If you have an adjustable or automatic camera that accepts an accessory flash, perform all the usual steps to take a flash picture (see pages 40 and 152-157). Set the camera for the sunlit situation, but select a shutter speed that will synchronize with the flash generally 1/60 or 1/125 second. A mediumor slow-speed film may be helpful. Then position your subject at a distance that will require more flash power than your flash unit can provide. You want the flash to fill the shadows subtly, not overpower the sunlight. See pages 160-161 for more on fill-in flash.

Overcast sky

From above

Another way is to use a flash unit on your camera to add a little brightness to the shadows. Photograph your subject from a distance where the flash provides a little less than half the light necessary for proper exposure. (See pages 160-161 for more information on flash-fill exposure.)

Light shade or overcast skies give more appealing pictures of people than direct sunlight. You'll get open, easy expressions without dark shadows. Since there's less light in these conditions, an automatic camera will automatically give more exposure. With a manual camera you'll have to make the necessary adjustment. (See pages 136-143.)

You can subtly change a person's appearance by changing the camera angle. A person photographed from above, a high angle, seems smaller and less important than someone photographed from below, a low camera angle. When the camera is aimed from eye level or a bit below, the effect is called normal. Most people prefer to be photographed at eye level. Be careful that an unusual camera angle doesn't distort your subject.

Direct sunlight

From below

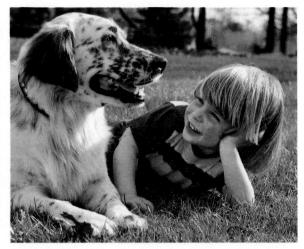

At eye level

People wear natural expressions when they're occupied. Look through the viewfinder at the entire scene. Make sure that no clutter in the background or foreground interferes with your view of the subject. Move in close to the person—close enough to keep only the essential features in the picture. (If using fill-in flash, move in only as far as good exposure will permit.) Another way to keep foreground and background simple is to change camera position and angle until you see exactly what you want in the viewfinder. You can also control depth of field so that the person is sharp and the rest of the scene is blurred. (See page 144.)

People wear natural expressions when they're comfortable. Try to have your subjects in relaxed positions—leaning against something or seated. When people have something to occupy their hands and attention, you'll get authentic portraits. Make sure your model is wearing clothing he or she finds appropriate and that is acceptable to your eye for colour, coordination, and neatness.

Depth of field

Large aperture-f/2

Small aperture-f/22

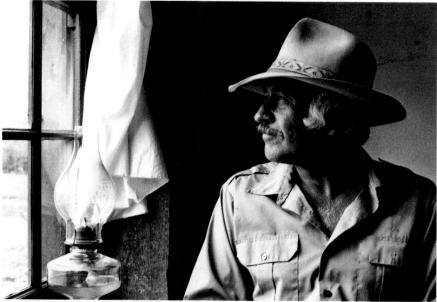

Window light

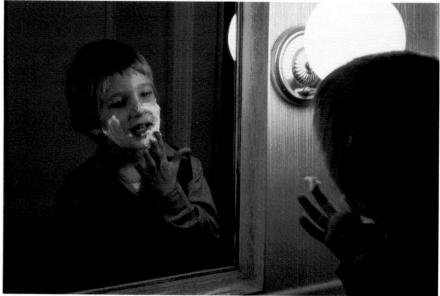

INDOORS

Most of the outdoor guidelines apply to making effective portraits indoors. You want people to be comfortable, relaxed, and to appear in pictures as they do in day-to-day life. Seated comfortably in a pleasant spot with an attractive, simple background is one answer. An alternative is to engage your subject in an activity that is interesting, familiar, and appropriate, such as a hobby or sport.

Again, lighting is important. You'll find four possible sources for indoor light: existing light from outdoors shining through a window or a door, artificial light given by tungsten or fluorescent bulbs, flash, and strong tungsten bulbs in reflectors called photolamps. (See next page.)

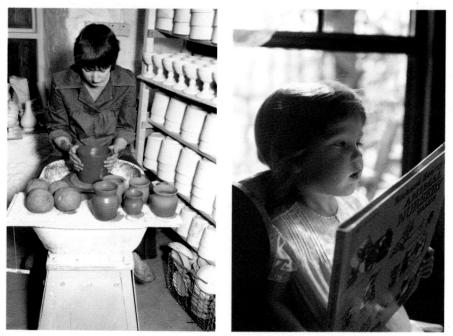

Flash

Window light reflected from book

Existing Light The existing light* looks best, of course, whether it's from the outdoors or from artificial sources such as household lamps. If you use light from the outside, move your subject close to a window or doorway, positioned so that lighting on the face is even and so that your picture will not include much of the bright window or doorway. The bright area could fool an exposure meter or automatic camera into underexposing the subject's face. A reflector can brighten the shadows caused by light from a single direction.

Taking pictures by household lamps requires fast film (ISO 400), slow shutter speeds (1/60 second or less) and wide apertures (f/2.8 or larger) because normal home lighting is much darker than daylight outdoors. Pose people near bright light

Using Photolamps

Create effective lighting with photolamps. Bulbs and reflectors are sold by photo, hardware, and electrical dealers. One lamp, reflecting off a wall, will give a pleasing portrait. Three lamps give many lighting possibilities. Using an exposure meter or an automatic camera should give good exposure.

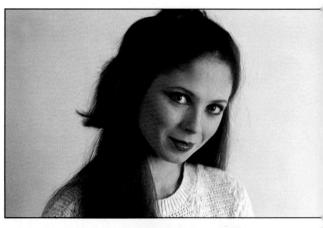

Using a single lamp.

sources, but don't include those lights in your picture. Try to have the lighting as even as possible on the person's face. When the lighting is extremely dim and you need a shutter speed slower than 1/30 second, mount your camera on a steady support such as a tripod for sharp pictures.

Tungsten bulbs give a different colour light from daylight. Use a high-speed film designed for tungsten light or use daylight film with an 80A filter attached to the camera lens[†]. In fluorescent light, also a different colour from daylight, use daylight film and a CC30M filter[†]. Otherwise, your pictures may have a greenish tint. If you use KODACOLOR VR 1000 or 400 Films for colour prints, you can expect good results without a filter. *See pages 162-165 for more on existing light.

*See pages 166-177 for more on filters.

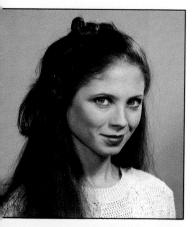

Three lamps.

Using An Exposure Meter

Many advanced automatic and adjustable cameras allow you to make some decisions about setting the camera for unusual lighting conditions. These cameras generally have a built-in exposure meter that either gives you advice on how to set the camera yourself or makes the adjustments for you. Older adjustable cameras may not have a built-in meter. If yours doesn't, you may know how to operate a handheld meter.

The best advice for using any meter, built-in or handheld, is to make a reading as close as possible to the subject, excluding the meter or camera shadow. Make your settings as the meter indicates from the close-up position. If the camera is automatic, there is usually some way to override the automatic setting feature in unusual exposure situations. Take a meter reading close to the subject and then back off to your preferred camera position. Adjust the camera manually to keep the exposure settings recommended by the meter at the close position. For a better understanding of exposure, see pages 136-143. For better understanding of how your particular camera operates, check the instruction manual.

Flash Flash, of course, is one of the most popular sources for light in dark places. Electronic flash units are available for most cameras, and the cost per flash is very low. Many units are automatic within certain distance ranges, allowing sufficient exposure without further adjustment. As with photolamps, a single flash will provide enough

Flash Pictures

Flash photography is easy with nearly any camera. Most snapshot cameras are equipped for an attachable flash device such as a flipflash or an accessory electronic flash unit. Some snapshot cameras have built-in electronic flash. Attach and/or turn on the flash device or unit; make sure that your subject is in the flash distance range, and take a picture. Allow the ready light on an electronic flash unit to glow before you take the next picture.

With 35 mm cameras that have built-in flash, you turn the flash on, focus the camera if necessary, and take a picture. Adjustable or automatic cameras that accept accessory flash units may require some adjustment. Some dedicated systems may need to have a particular aperture set on the camera. More sophisticated dedicated systems may need other settings.

Automatic, self-quenching flash units operate in several distance ranges at different aperture settings, depending on film speed. Determine the typical distance you'll be photographing, and choose the appropriate mode on the flash unit. The unit usually requires a specific aperture setting for each flash mode.

With a manual flash you set the film speed on the calculator on the back of the flash unit, then focus on the subject. Look at the lens distance scale to find out camera-to-subject distance. Refer to the flash calculator dial and find the aperture to set on your camera—it will be approximately opposite the camera-to-subject distance. There's a lot more to know about flash photography with automatic and adjustable cameras. See pages 152-161 for more information.

Using Flash

The most important guide for successful flash photography is to keep within the flash range. For snapshot cameras, the range might be 1.2 to 3.5 metres. With more advanced flash, the range may vary. Check the instruction manual for your camera and flash.

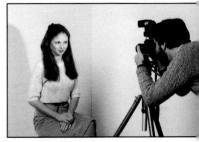

Direct flash

light, but it may be rather harsh. Bounce the flash off a light, neutral-colour wall, ceiling, or white card for a softer light more suitable for portraiture. Flash exposure depends on flash-to-subject distance. For more information on flash exposure and bounce flash, refer to pages 154-159.

inced flash

Bounce Flash

Bouncing the flash off a ceiling or wall softens the harsh effect common to direct flash. It's easy with most cameras that accept accessory electronic flash units.

Some sensor-automatic electronic flash units will function automatically when you tilt the flash head toward the bounce surface. The sensor must remain aimed at your subject. Use the automatic mode that requires the largest lens aperture (smallest number), and stay well within the maximum flash range. Automatic units that have fixed heads must be used manually, as described below.

With a manual electronic flash unit or with one that has a fixed (non-tilting) flash head, you must remove the flash from the camera. You'll be able to connect flash and camera with a special electrical cord (PC-cord), sold by photo dealers. Make settings as follows. Determine the approximate distance that the flash will travel from flash to bounce surface to subject and use that distance to find the corresponding lens aperture on the flash calculator. Increase the recommended lens aperture by 2 *f*-stops and you have a good starting point for successful bounce flash exposure.

An effective bounce surface should be lighttoned and neutral coloured to reflect as much light as possible and to give natural colour appearance. Make sure to aim the flash at a point midway between you and the subject so that the lighting will be even.

CANDID PICTURES

The word candid applies to family holiday celebrations as well as to stalking an interesting character on your travels. Your challenge is to photograph people in a natural atmosphere without calling attention to yourself. The reward is capturing the genuine emotions and expressions that give real clues to character.

There are two approaches to candid photography. One is to immerse yourself in whatever is going on, wait until the participants lose interest in you and resume their activity, and then start taking pictures. You can get totally natural, unselfconscious expressions—real slice-of-life material. The other way is to find an unobtrusive position where you can remain unnoticed and take your pictures from a distance. Unless you use a camera that accepts auxiliary telephoto lenses, your subjects may appear a bit too distant. A normal or wide-angle lens such as that found on most snapshot or automatic cameras, actually helps you get good results when you're in the middle of the action as described at left.

It may be helpful to preset your focus and use a small aperture, a fast shutter speed, and a fast film. This way you can concentrate on your subjects rather than divert attention to your adjustments.

CHILDREN

Children resemble adults in many ways, except that they're smaller and faster. Because they're smaller you must move closer to get a full-sized image in your picture. You'll also have to get down for an eye-level view. Children behave more naturally when the photographer is on their level.

Because they're so fast, you'll want to take the following precautions. Use a fast shutter speed— 1/250 second or faster, if possible. Use flash indoors to capture the movement. Don't ask for poses or antics until you're completely ready to shoot. Use a high-speed film that will allow you a small aperture for maximum depth of field. (See page 144 for more information about depth of field.) The greater the range in acceptably sharp focus, the better chance you'll have to get sharp pictures of a quick youngster. Needless to say, if you have a game or some activity prearranged in a certain location, you should have all the time you need to take fine pictures while the child is occupied.

Most children have soft, clear skin that doesn't improve with harsh shadows. Backlighting, shady spots, and overcast days will portray any child's smooth complexion. Above A child's discovery can provide memorable pictures. Make sure to move close. Get down for a better view of the activity and the expressions. Be ready for one or more special moments.

Right

The soft light from a shaded window gently illuminates the subtle tones of a child's skin. Because such a scene is fairly dim, consider a highspeed film for sharp pictures.

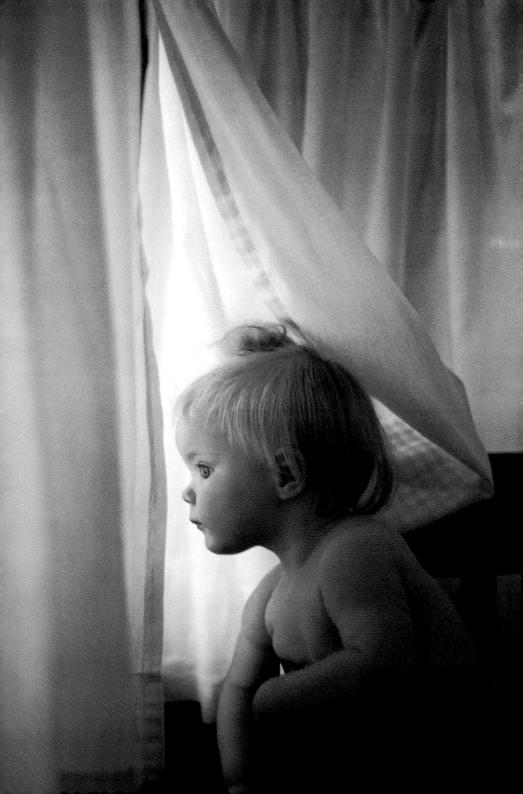

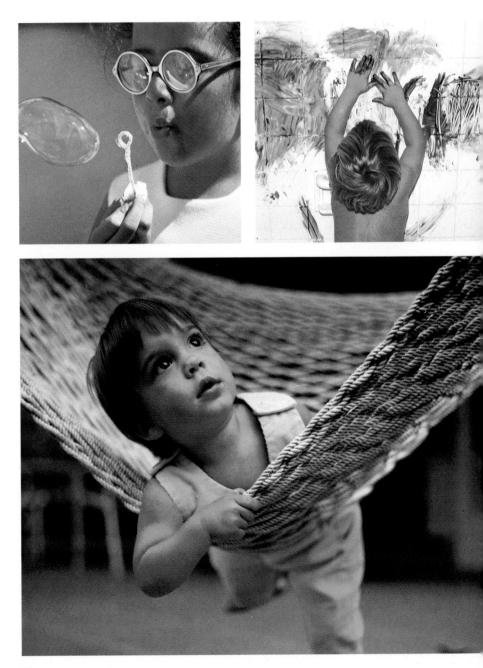

PEOPLE

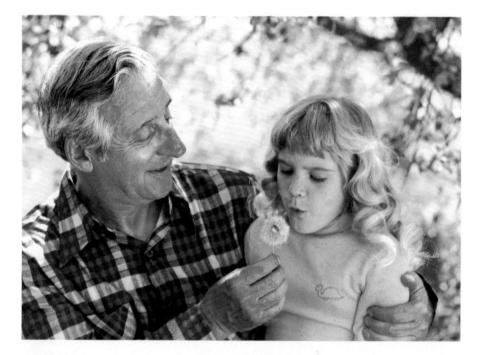

ELDERLY

A flattering portrait calls for soft, even lighting that will play down wrinkles and/or other complexion irregularities. Such a portrait might be made outdoors in the shade or on an overcast day or indoors with indirect light from outside. Bounce flash provides another possibility. Your subject will be more relaxed and comfortable if involved in one of his or her normal activities, and you'll get more natural expressions. Remember, keep the picture simple by avoiding or removing objects that will clutter or distract.

On the other hand, if you want to emphasize character displayed in a weather-beaten face or in gnarled hands, you will want strong directional lighting to give shape to the lines and to enhance the texture. Sidelighting can be very effective for this, and it needn't be terribly harsh. Too strong a light will cause so much contrast that you'll lose the fine gradations between highlight and shadow.

WEDDINGS

The volume of emotion at a wedding is usually far greater than at any other occasion. To the amateur photographer this is doubly important. First, you'll see more potential pictures than you can probably take. Second, the pictures you do take can have a rich significance in the years to come.

Since everyone wants to have a good time, including the photographer, try to plan ahead. Figure out what activities you want to record and ask the bride for a timetable and a list of locations. Check to see if you can take pictures in the church—particularly if you plan to use flash. If you feel strongly about planning, visit the locations beforehand to choose picture-taking spots and to choose what films you'll want (if there's a possibility of taking existing-light photos).

The next important step is to anticipate possible activity spots before a crowd gathers. This way

Getting ready.

you'll have the best vantage points. Take plenty of pictures. If you think you missed the most dramatic moment of the cake cutting, for instance, persuade the couple to do it again. Incidentally, let the professional photographer cover the wedding without interference. Professionals are fast and decisive and usually will allow you plenty of opportunity to get great shots.

One advantage you'll have is knowing some of the family and guests. Watch the live wires of the crowd for delightful candid snapshots. These informal pictures you'll take of people and happenings between the main events will be treasured by all concerned, particularly the bride and groom. In fact, you can give a very nice after-wedding present, if you make up a small album of your best shots. Everyone remembers weddings through pictures—the more the merrier. People at weddings are usually paying attention to the proceedings. You get great opportunities to capture friends and relatives being themselves. If you have a loaded camera, ready for action, you should get a wonderful collection of memories.

PLACES

Landscapes closely follow people in popularity with most photographers. The reasons are as varied as the pictures, but several stand out—landscapes are beautiful and interesting; they provoke the imagination, and they provide a photographic challenge. Transferring the appearance and emotion of the scene from the mind to the film has been a lifetime quest for some photographers.

How often do photographers revel in the panorama stretched before them only to sigh with disappointment when they view their pictures? Although there are a number of hints that we'll discuss for better scenic shots, the most important advice we can give is: analyse *why* you're struck by a particular view and try to transfer your feelings to camera techniques. Ask these questions:

- 1. What elements of the scene interest you most? Trees, mountains, water, etc?
- 2. Do you want mostly sky, land, or water?
- **3.** Is the scene more interesting as a horizontal or as a vertical?
- 4. Are colours or shapes more important?

Only you can answer these questions, of course, because you are the one who will be looking at the scene. The next few pages will offer some tools to help you get the answers into your pictures.

Pictures are reminders. As time passes, the memories get dimmer and dimmer. Moods and feelings are particularly difficult to recapture. Pictures help keep those memories bright—memories of the places you've seen and the wonders that leave you breathless. It's important to consider some of the ways to capture the sensations you feel in a particular place. Lighting and camera position are especially important. Notice in the picture at right how the slanting shadows of early morning help to define the shapes and bulk of the seaside cliffs? See also the subtle impression of distance offered by the haze in the scene. These ideas and others will be discussed in this chapter.

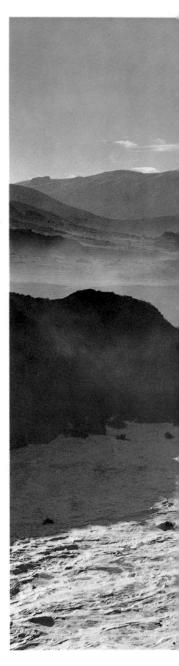

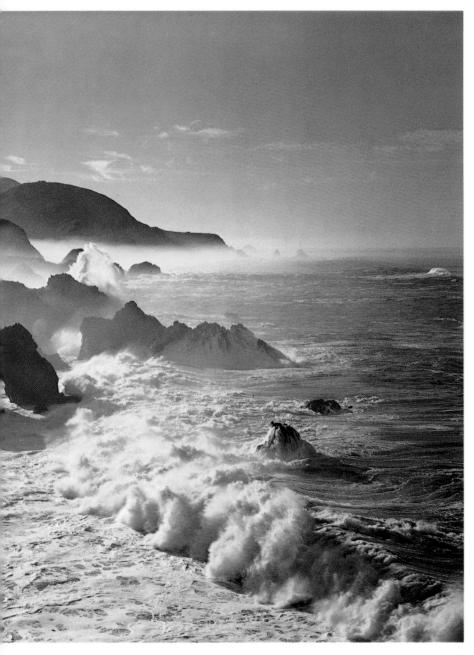

Question 1. Whatever part of the scene interests you the most, concentrate on it. No matter how vast the sight, you need one important centre of interest. Otherwise the picture will lack impact. Making your camera respond generally means moving closer (making the subject bigger) and possibly shifting angles to eliminate anything extra and unwanted.

Question 2. If the sky is an important element in the picture, aim the camera to capture more sky, less land. If the sky only provides a horizon, aim the camera down for less sky.

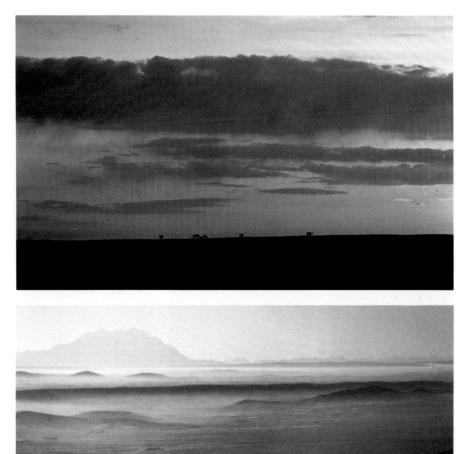

Question 3. If the scene is broad and magnificent, such as a mountain-range horizon, hold the camera horizontally. If the scene seems to stretch from your toes into the distance-a river or a highway-for instance-then hold the camera vertically.

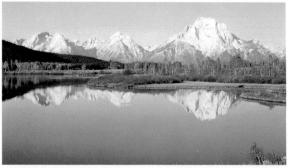

Horizontal

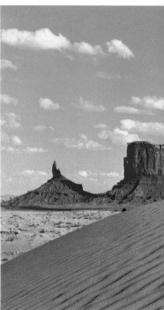

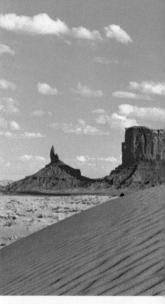

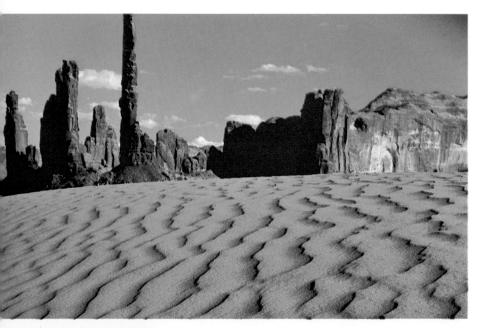

Question 4. Sometimes dark shapes and light shapes interact in a way that catches your eye. Find a position and aim your camera so that you concentrate on those shapes only. Anything else in the picture only serves to dilute the image. At other times you'll see colours interplay in a provocative way. Again, choose a location and aim your camera so that the areas of colour dominate the picture.

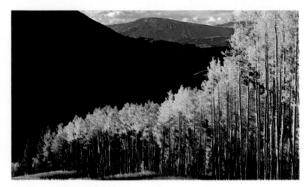

Dark and light shapes.

Composition

Good composition means placing the elements of a picture in a harmonious, interesting, and even unusual way to capture attention. In setting up a composition, consider the following:

Balance Do you want a symmetrical arrangement or a casual collection? A symmetrical design has obvious balance. But even an informal composition is balanced so that it feels complete and stable. Colours, shadows, and light areas tend to balance each other, and are affected by big shapes, little shapes, distance, and lines.

Rule of Thirds A traditional way that artists have grouped elements in pictures is called the rule of thirds. Place the centre of interest and important subordinate elements near intersections of vertical and horizontal lines at 1/3 points of the picture.

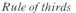

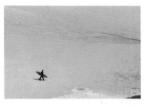

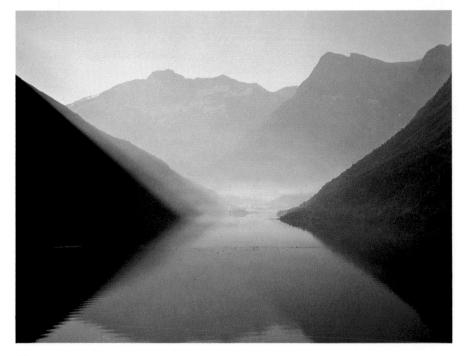

Framing

Scale

Perspective How do you make a two-dimensional picture express the depth and vastness of a three-dimensional scene? Carefully. Here are ideas.

Framing means almost surrounding your distant subject with some nearby foreground material, such as overhanging branches. The contrast between the near objects and the distant subject can help to establish distance. Framing is also helpful for disguising a dull, boring sky or hiding unwanted scene elements.

Similar to framing is the general use of objects in the foreground as subjects for scale to measure the background. Almost anything can be effective: a car, tree, boulder, relative, motorcycle, boat (on water, or course), cabin, and more. The size of your scale subject will help give an impression of distance. If too close, viewers will forget the scene. At a medium distance the comparison may be most striking; at a greater distance the reference presents a more subtle view, but the viewer who stops for a second glance may be awed by how the landscape swallows up the extra subject.

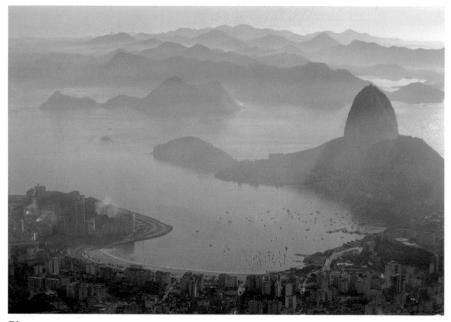

Planes

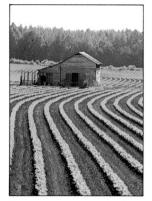

Lines 80 **Planes** Some stunning views, particularly from high up in the mountains and desert, show subjects at different distances. Parallel mountain ranges (running across your field of vision) become hazy as they become more distant. This phenomenon is called aerial perspective. It is particularly obvious in the photo above, taken in Brazil at an earlymorning hour when mist still shrouded the conelike peaks. In the desert, beige sand turns foggy blue near the horizon. Use these separate planes of different colour to help establish distance and scale.

Lines Lines that lead far into the scene can also help establish distance. A fence, a row of telephone poles, a road, or a river, all shrink as they recede from the camera, and this will be captured on film. Lines can also help to draw near and distant areas together into a harmonious picture. The cultivated rows in the picture at left provide continuous threads that link foreground and background into a single, tranquil scene.

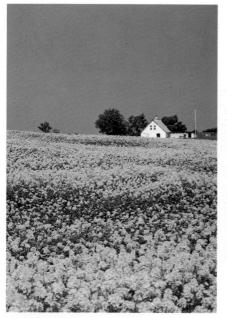

Frontlighting

Backlighting

LIGHTING

Lighting Angles If you recall the discussion of lighting angles in the "People" section (page 51), you'll remember frontlighting, sidelighting, and backlighting. Although generalizing is always dangerous, sidelighting may be the most effective landscape lighting. Perhaps it's wise to broaden sidelighting to include any angle that does not produce direct front- or backlighting.

You need shadows to help show distance. Frontlighting gives no shadows. Backlighting can give dramatic shadows, but your subject may become a silhouette. Sidelighting from a wide series of angles casts shadows that help you gain an illusion of perspective. Waiting for the right times of day or carefully choosing your position may be the best answers.

Sidelighting

Time and Light As you've noticed, the landscape changes appearance dramatically from dawn to dusk and throughout the seasons. Obviously, seasonal changes mean green leaves, red leaves, or no leaves, as well as snow or soft grass. But the subtle changes come with changes in the light. Winter light is harsh but weak; summer light is rich but often oppressive. Sunlight in autumn and spring is bright and cheerful. At noon the sun's rays beat straight down, flattening form and perspective. Early in the morning and late afternoon the light is a rich, warm colour and long shadows streak across the scene.

Although you can't always choose the season, especially when travelling, you can often select the best time of day to make your landscape photographs. Early morning may be misty with light of a delicate rose colour. Shadows are soft and violet, and the distance may be smoky. At noon the smaller shadows are hard and dense. Distance may be difficult to show. In the late afternoon, the light becomes more orange and the large shadows are warm and rich. The distance may be clear but will contrast in blue against the warmer foreground.

TRAVEL

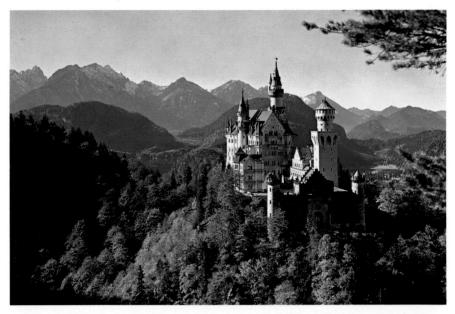

Many people take most of their year's pictures during holiday or travel times. They see new sights and enjoy exciting experiences—experiences they want to deposit in their memory banks and share with others.

Travel photography combines all the elements discussed in this book—people, landscapes, interesting objects, flowers, night scenes, and sports. The challenge is being ready for all at the same time. Here are some general ideas, followed by specific tips that should make your travel photography easier.

Research As you plan the details of your trip, list important sights that you'll want to photograph. Then you'll have a ready reference to assist your memory. Of course, you'll find special places of interest not listed in any guide book. Many of these will give your pictures a more authentic local flavour than the customary landmarks—the earlymorning marketplace, people involved in unique craft work, unusual methods of transportation, and, of course, the preparation of those special meals. Early-morning shadows and foreground branches create perspective in this gorgeous view of Neuschwanstein Castle near Füssen, Germany.

Right

Pictures of people add character to your travel memories. Ask permission and get a winning expression from a classical dancer in Cochin, India.

Take Plenty of Pictures Once back home, the typical sentiment is, "Why didn't we take more?" Film is a small part of your travel budget, but the pictures will be a large part of later enjoyment.

Look for the best angles and positions from which to photograph your subjects. Sometimes you'll find that you can improve the composition of your first picture by shifting your position.

When photographing colourful, fast-moving events, keep looking through the viewfinder. Take pictures as often as you see something you like.

Many Subjects be prepared to move in close, with permission of course, to people in native or ethnic dress. Photograph camel caravans, shop windows full of curios, floral displays, festivals, parades, local sports, children, building interiors, and illuminated sights at night. Remember that many of your best-treasured pictures will be of the subjects you found unique—the ones that you reacted to most strongly. Also, don't worry about bad weather. Fine photos can come from inclement conditions umbrellas in the rain, fishing boats at anchor in the fog, and children playing in the snow.

Be Prepared Keep your camera with you at all times, ready and loaded, and be alert for good picture situations.

Tell a Story Your travel pictures should describe the holiday as completely as possible. Don't forget to capture events that will help you remember. Aeroplane flights, train trips, taxi rides, customs officials, hotels, tourguides—all these contribute to the later enjoyment of your holiday. Many travellers photograph signs as memory joggers. Signs are even better when familiar faces surround them.

Personalize Your Pictures Have family or tour group members pose in pictures of monuments, scenic views, restaurants, and with the helpful local people you'll meet. You'll delight in the warmer significance of these scenes later.

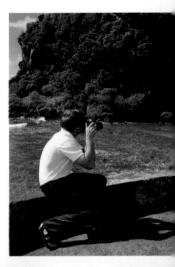

Tips Here are some specifics that might help.

- 1. Before you leave home, look at your list of possible pictures, and pack about twice as much film as you think you'll need.
- 2. Allow enough time to take a roll of film with your camera and have it processed before you leave. It's a good way to make sure that your camera is operating correctly.
- 3. If you have an expensive camera, make sure that you carry evidence that it was bought before you left the country: ideally, take photocopies of sales receipts. If you do not have these, you may have to pay duty when you pass through customs on your way home. If you no longer have a receipt, make out a list of the equipment and ask for this to be signed by a customs official on your way out.
- 4. Don't forget flash pictures. Take whatever batteries, flash devices, or current transformers you'll need.
- 5. When passing through airport security, ask for hand-inspection of your camera and all film, exposed and unexposed. It's not always possible. Security X-rays can be harmful to your film—the more X-rays the worse the harm. Anytime you avoid the X-ray scanners will help the final results.
- 6. Write down the address of your photofinisher or laboratory before leaving, then post back your films while you are still abroad. This way, you can avoid airport X-rays and your prints or slides could be waiting when you return.
- 7. It is a sensible practice to examine your camera at night after touring is finished for the day. Clean the lens if necessary, and check the battery if your camera uses one. Make sure that the carrying strap is secure.
- 8. Keep your camera with you—to avoid theft and to keep ready for picture opportunities. An unattended camera can be an inviting prize.

PETS

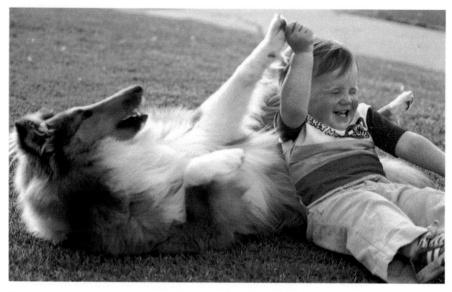

Pets have as much personality as people, and pictures should communicate those traits. You'll need some ingenuity, lots of patience, and a good location. Small animals, of course, can be photographed nearly anywhere. Larger pets will give you less choice. Above all, find a setting that appears natural.

Animals, like children, have limited patience and a short attention span. Set up your camera and

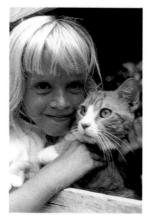

Horses might be best in a field.

A working dog might be best in a field, a house cat on a window sill or in front of the fire. Try to keep the background simple.

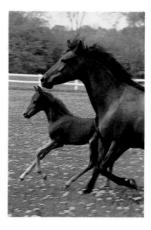

Flash is an effective way to separate a small animal from confusing surroundings indoors. Flash can also stop quick movement. Move in close enough to eliminate other elements in the picture.

Make sure that you stay in the minimum focus range of the camera. Also, see that you are still within the flash range of your camera. If you are still in focus, but too close for the flash, put one or two layers of white tissue over the flash to cut down the light. When you're all set to take a flash picture, try to spark an interesting expression.

get completely ready to take pictures before you bring your subject on stage.

Ingenuity means keeping your pet in the same place and evoking appealing, enthusiastic expressions. Find or devise a noisemaker that will prick up your pet's ears for an alert look. Getting a pet to stay may call for a morsel of favourite food.

Be patient. When you see what you want, take plenty of pictures. Pets soon grow restless.

Get fairly close—enough so that your subject fills the viewfinder. Place the camera down at the pet's eye level, just as you would for a small child. The perspective gives a less distorted view, and animals appreciate the eye-level approach.

Some animals have special photogenic habits. Famous animal photographer Walter Chandoha made one of his first commercially successful pet photos of his cat Minguina, who made a long stretch in front of a mirror after every nap. Chandoha got ready and snapped her in the middle of the stretch—just what an eager art director wanted for an advertisement.

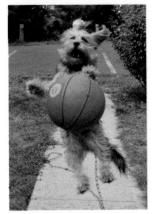

Most pets can move pretty fast when inspired. Practice the stunt you want to capture with an unloaded camera. When everything looks right, start taking pictures.

ZOOS

Everybody likes the zoo, and your zoo photos should show it. You can take pictures of the animals and pictures of people enjoying the animals. For best results in photographing the animals themselves, get as close as safely possible. Dangerous inhabitants are usually behind bars, wire, or glass. From behind the barriers in a safe position, aim your camera through the wire or between the bars or put it right next to the glass. Make sure to stay behind zoo-imposed barriers. Wild animals are always unpredictable. There's no sense offering yourself as a free meal if the zoo has already provided one.

Where there are fewer restrictions, it's easier to get unobstructed photos. As always, see if you can find a position with superior lighting and background. Move around until you find the best.

The children's zoo is often one of the most fertile areas for great spontaneous pictures—especially with your kids. Most youngsters are thrilled and awed by all the furry, friendly creatures, and their faces show it. Move in close enough to capture those rapturous expressions.

Some zoos have indoor displays where you can take flash pictures (pages 152-161) or existing-light pictures (see page 165) of the exhibits. Put camera and flash next to the glass where possible. Where you're separated from the glass, take your pictures at an angle so that flash reflections won't bounce back at your camera.

You can get fantastic results at the attractions where spectators are caged inside cars and the inhabitants roam free. The wild animals are familiar with cars and will venture quite close. Use extreme caution, however, and carefully obey the rules. A charging carnivore has more primitive things in mind than portrait photography. If you're in a car with the windows down, just stay inside the window. If the windows are closed and the car is moving, hold the camera next to but not touching the glass. You'll avoid reflections and get sharper pictures. Use as fast a shutter speed as possible to overcome car or animal movement.

Surprisingly, time of day may be important for zoo pictures. At peak visiting periods during the weekend, the animals may retire to their hideaways just to avoid the crowds. Midday is usually a time for napping in the animal kingdom. Try to schedule a special trip with friends or family to see the creatures when they're likely to be most active-during the week, preferably in the morning before feeding time.

FLOWERS AND PLANTS

Any flower garden is a cornucopia of nature's greatest treasures—dazzling colours and soft fragrances combined in a master patchwork of cosmic design. Some "gardens" are wild, growing free, while others are carefully planned and cultivated. In either case, there are some simple techniques that should give you exciting pictures.

Concentrate on the garden—move in close enough to picture only the blooms. Better still, take pictures at different distances to show the overall view and then smaller segments of floral glory. Get very close with close-up lenses. (See page 182.) Move around so that you have the best background and picture design. Take pictures when the light makes nature's work most attractive. The best times are early in the morning with soft shadows and sparkling dew or the rich warm light of late afternoon.

Take pictures throughout the growing season so that you have a complete record to share with distant friends or relatives.

Look for exciting pictures of nature subjects in all the seasons. Autumn leaves, snow-covered pine needles, and the first crocuses give extra dimension to the year's picture-taking.

Close-Up Tips A piece of harmoniously coloured paper will provide a simple background that concentrates attention on your subject. Flash or a piece of white cardboard will reflect light into shadow areas. Since you'll be very close, cover a flash with two or more layers of tissue for correct exposure. If the breeze is batting your subject around, make a quick windbreak of tomato stakes and sheet plastic. For that extra-fresh look, create some artificial dew with an atomizer.

BUILDINGS

What's important about a particular building? Or, rather, why do you like a special building? What are the features that attract you? Once you've isolated these aspects, concentrate on them.

In the illustration above, the photographer sensed peace and stability in the weatherbeaten harbour structures. This feeling is augmented by the nearly perfect reflection. Although cropped for

best page design, the breadth of the long low buildings is captured by horizontal framing. The misty surroundings create a mood of New England nostalgia which seems to await the arrival of a transatlantic square-rigger. Another case might show a martial line of brilliantly painted terraced houses. Naturally, you'll want to capture the pattern of the group, as well as individual details.

Details might be ornate or stately entrances, wrought-iron work, or designs in the brick or stonework of the facade. Again, wait for a time of day when the light shows off your subject, and move in close to isolate what you want to capture.

COLLECTABLES AND OBJETS D'ART

Many hobbyists make or collect things that they want to show other like-minded people. They also see things on disply that they want to record. Same important rules-move in close (with a close-up lens, if necessary. See page 182). Find a camera position that sees a simple background, and use lighting that shows off the object's best features. If necessary, use reflectors to fill in shadows. One good way to control your results is to cover a table with plain cloth or paper, preferably not white, that contrasts with your subject. Raise the cloth or paper up out of sight in the background to provide an undistracting backdrop. Outdoors in sunlight you can control the lighting by turning the table. Indoors with photolamps (see page 58), you can move the lights.

The free-form ceramic statuettes pictured at left were photographed in the set-up shown above. Indirect window light provided the main illumination, while a white reflector card filled the dark-side shadows.

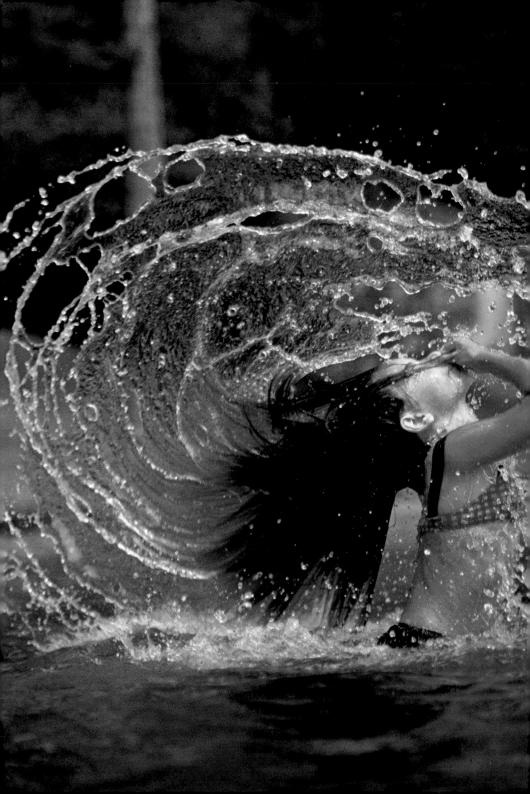

ACTION

There are some familiar ideas for capturing action successfully as well as several specific techniques. Following a few general tips are ideas about portraying movement.

Get as close as you safely can. Choose a position that will dramatize the incident. Look for an uncluttered background and good lighting. Preset your camera controls and focus on the spot where you plan to capture your subject. When the moving body arrives at the spot, snap the picture. When composing the picture, leave a little room in front of your subject—it looks more natural.

STOPPING THE ACTION

You can usually freeze movement sharply in one of four ways. You can set a fast shutter speed on your camera (see pages 138-141). The faster the shutter speed, the more likely your chances of a sharp moving subject. Camera position will help, too. You can also catch some movement at its peak, or you can pan your camera with the subject.

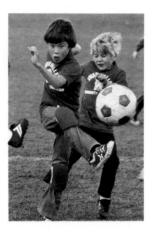

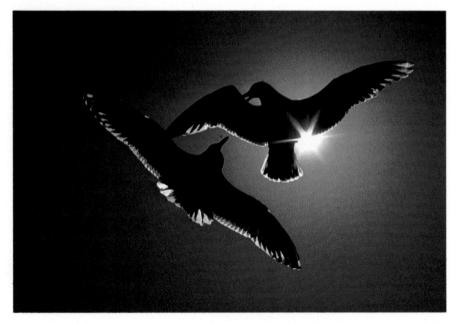

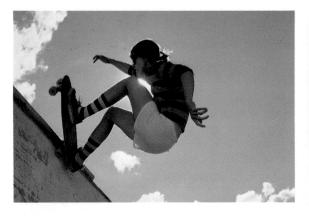

Peak of Action Some motions have a midpoint where everything stops momentarily. A diver at the top of an upward spring or a polevaulter up above the bar both stop before descending. A cricket batsman, a tennis player, a golfer all pause before moving and stop after follow-through. Practise for a while without film. Follow a diver to the mid-air pause and pretend you're snapping that fraction of a second. Get a golfing friend to practise swings. See if you can capture the stationary highpoint of both backswing and follow-through.

Panning Panning works with running kids, dogs, horses, bikes, sports cars, speed boats, or planes during take off. You may have to pan for two reasons. First, the subject may be moving so fast that even a fast shutter speed cannot stop the action. Second, good composition is difficult because the subject is in your viewfinder for such a short time. Swing both your camera and body so that the moving subject stays in the same place in your viewfinder. This, too, takes practice. Rotate your body smoothly and concentrate on pressing the shutter release at the best point for picture design. Follow through after you snap the shutter. Unless you can choose a very fast shutter speed. chances are good that the subject will be sharp and the background will be blurred into attractive streaks of colour.

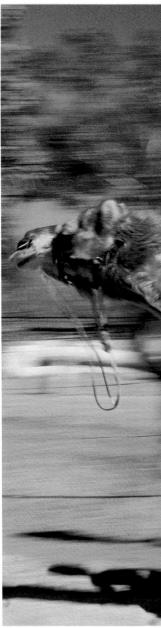

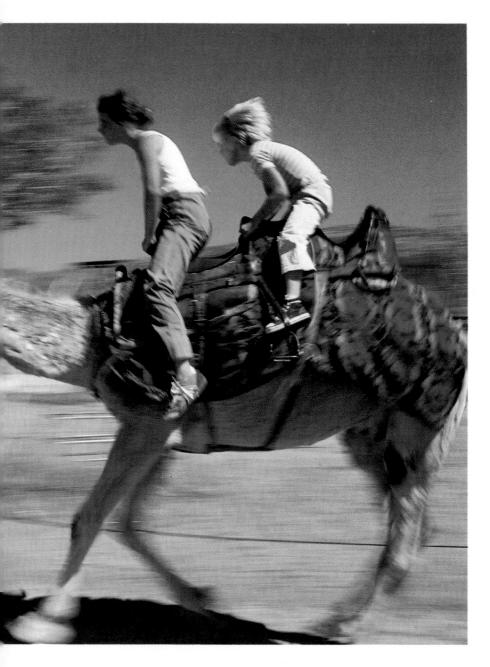

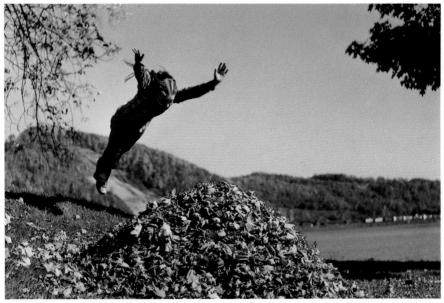

Toward the camera

Direction The direction of movement may affect your choice of technique. A subject coming toward or retreating from you is easier to capture sharp than one crossing your field of vision. You can use a slower shutter speed for action toward or away from you, and you'll find that you have more time to make a good composition. Subjects moving at a 90° angle to you and your camera invite panning and your fastest shutter speeds.

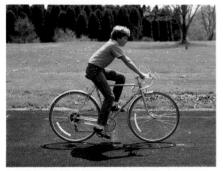

1/500 second at 90°

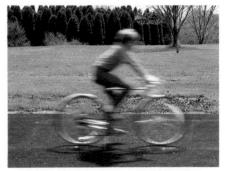

1/30 second at 90°

BLURRED ACTION

Blurred motion can convey the idea of speed and movement. Set a very slow shutter speed (1/30 to 1/8 second) on your camera. You can pan or hold the camera steady while the subject's blurred movements cover a little bigger slice of time on your film. When the camera is mounted on a tripod or other solid support, only the subject will be blurred. Add your own movement by handholding the camera.

SPORTS TIPS

Get close to the players. Ask permission for a sideline spot at amateur and school competition. At professional events choose an unobstructed position as near the action as possible.

Prefocus on the spot where you'll get the best picture. Have your camera loaded and the exposure controls set. It's very helpful to know the game, because you can anticipate key plays and key players. Photograph night games and indoor events by the existing light. See pages 162-165.

NIGHT

The world spends half its time in light and half in darkness. Picture-taking at night can be just as exciting as daytime photography.

You'll find subjects everywhere—bright lights, fireworks, holiday displays, and outdoor activities. Snapshot camera owners can use flash outdoors at night. A high-speed film will extend the flash range. Owners of automatic or adjustable cameras can take pictures with flash or with the existing light. High-speed films, slow shutter speeds, and a large maximum aperture will help capture almost anything that can be seen. See pages 162-165 for more existing-light recommendations.

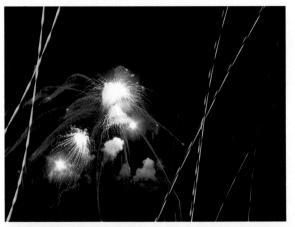

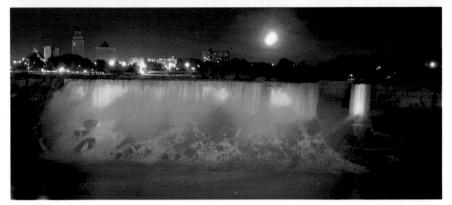

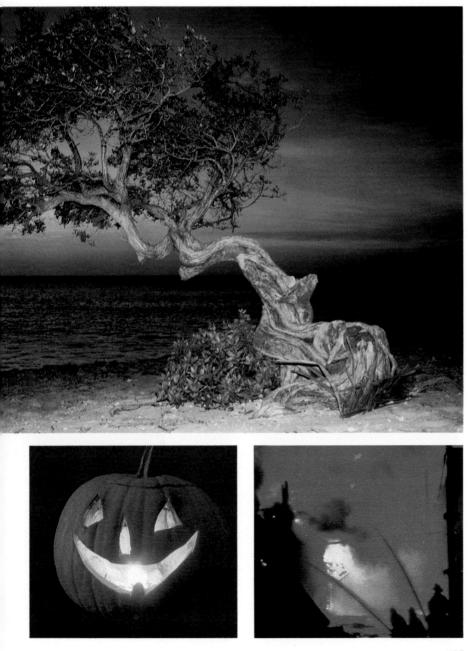

BAD WEATHER

Everybody takes pictures when the sun is out. But on some days, it rains, snows, mists, or is just plain overcast. The truth is that some of your best pictures can happen on days with poor weather. Think of the benefits.

People look their best out of the sun. Their faces open up with bright, natural, unshadowed expressions. Light overcast days are perfect for outstanding portraits. Just make sure that your background doesn't include much dull sky and move in close to your subject. You may even find that rain and snow give people, kids especially, an opportunity to wear colourful clothing and engage in activities you'll want to capture. In rain or snow, take care to protect your camera. Keep it warm and dry under a coat or parka.

Scenery takes on a very different appearance on a dull day. Although the sky appears gloomy and grim, the colours of grass and trees, red barns, and white fences can appear brighter. Fog will lend an ethereal quality to many scenes—subjects may appear partly shrouded in mist. Subjects may appear bluish in pictures made while the sun is hiding. Attach an 81A filter* to your camera lens to warm up the colours a bit. You won't need to change your exposure.

Snow and cold give a soft, blurry appearance in pastel shades. With your camera protected from flakes and the cold, you'll find a world full of children, sleds, snowmen, skiers, and colourful clothing. At night, you can take unusual flash pictures of nearby subjects with snowflakes hovering all around.

Rain brings some charming surprises; bright umbrellas and colourful rain gear, for instance. Reflections in puddles or on rain-drenched streets give another dimension to your pictures. Keep your camera out of the water, but don't hesitate to shoot activity in a rainshower. Find a good position to snap the action from under an overhang, or inside a car with the window open.

*See pages 170-171 for more on filters.

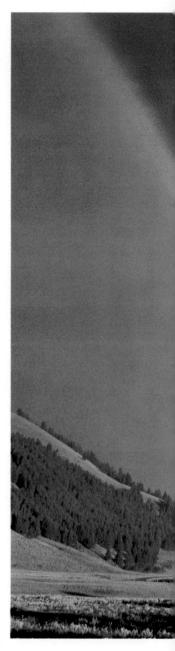

BAD WEATHER

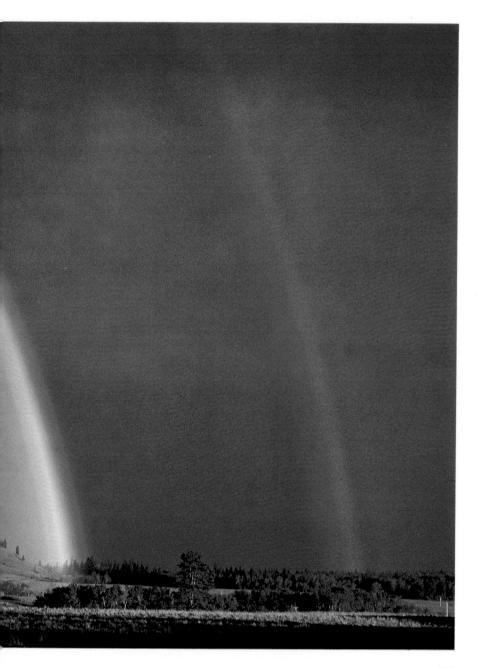

Overcast skies give delightful casual portraits, because your subjects won't be squinting into the sun. Try not to include much of the dull sky, and you'll find bright, colourful subjects all around. Again, high-speed film will help you get wellexposed pictures with a snapshot camera. Remember that your family and other people don't suspend activity when the sun goes in. Sometimes a gloomy day will inspire children to try something new. If they don't think of anything, suggest an interesting activity that will get them occupied and vield good pictures.

Mist or fog can lend a ghostly, ethereal appearance to familiar scenes. Nearby subjects will be distinct, but more distant subjects will seem to be

BAD WEATHER

fading into another dimension. Often, there's bright light coming through the mist, spotlighting bright objects or making trails through the heavy air. Early morning is a perfect time to search out misty scenes. If the sky is dark overhead, use a high-speed film in a snapshot camera.

EXPOSURE

Bad weather is darker, and you'll need more exposure than in sunlight. See pages 132-141 for film choice and exposure setting information. Automatic cameras, of course, will adjust to scene lighting with very little help from you. Use highspeed film in a snapshot camera.

SHOWING YOUR PICTURES

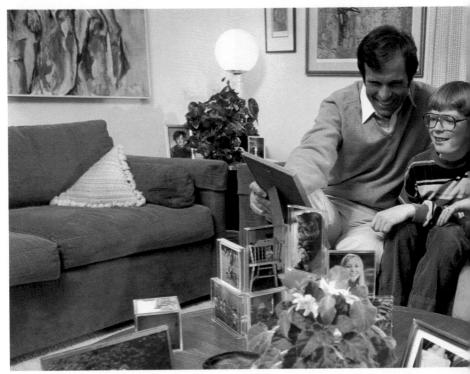

Good pictures are meant to be seen. Here are some ideas for getting more mileage from your best efforts. (Make sure you read page 115 for information about storing and protecting your photos.)

PHOTO ALBUMS

Albums abound in shapes and sizes from a pursesize book to coffee-table volumes. You can also make your own with a loose-leaf binder, thin cardboard pages, and photo corners or white glue. Many people assemble their albums chronologically—it seems sensible. They also label the pictures *and* the negative-envelopes so that they can get reprints at a much later date.

Some people get more in albums by cutting up the prints and inserting the best parts. There's wasted space in almost every print. A photo album can be the chronicle of years or an up-to-date newsbrief filled with your latest snapshots.

SHOWING PICTURES

ENLARGEMENTS AND HOME DÉCOR

Another way to get your best images out of the box and into view is to display enlargements. Available from your photofinisher in different sizes (for example: 13x18, 20x25, 27x35 cm) and shapes to fit your film format, enlargements are ideal for framing or for gifts. Hung on a wall, displayed on a desk, or even commanding an important place in your albums, enlargements have a powerful ability to cross the barriers of time and say, "You were there."

Traditional and unusual ways of displaying prints are available from your local photo, stationery, department, or discount store. You'll see frames in dozens of styles as well as such different ideas as photo cubes, wall clocks, mobiles, and collage boards.

GREETING CARDS

A card with a picture of you or you and your family is truly a personal communication. Children grow, houses change, and so do the seasons. You can commission special greetings from your photofinisher with pictures and words all printed together, or you can attach a print to the inside of other cards. Some people plan ahead and have favourite shots reprinted to enclose in letters to distant friends and relatives. A photo Christmas card each year keeps the people on your mailing list in closer touch with a growing family.

PROCESSING SERVICES

In addition to reprints, enlargements, and photogreeting cards, your photofinisher can make slides from negatives, prints and enlargements from slides, and copyprints from other prints. Some photofinishers can help you crop the negatives you want enlarged to improve the picture design.

Greeting cards for many occasions are available from your photofinisher. Can you guess which holiday cards receive the most attention?

STORING PICTURES

With a little care and forethought, your pictures will provide you with many years of pleasure. Here are some general ideas for prolonging the lives of prints, slides, and negatives.

Storage Locations You want a place with moderate temperature (under 21°C [70°F]) and fairly low humidity (under 50% relative humidity) which probably eliminates most basements and attics. Heat can become excessive in an attic, and humidity in either place may be harmful. A spot near a chimney, radiator, or in direct window light can cause problems as well.

Containers An album is the best way to display and protect your prints. Since the prints will be in intimate contact with the pages, make sure that the materials used in the construction of the album will not harm the prints. Check with your photo dealer about the cover, pages, plastic sleeves, mounting corners or hinges, and the ink used for identification. This becomes especially important if you have prints without the negatives. If you have the negatives, you can have them reprinted.

Album prints should not be subjected to pressure, nor should the image sides of the prints be in direct contact with each other. Protect the faces of the prints in an album with a suitable plastic sheeting. If you're making your own album, be sure that the adhesive you use for adhering the prints is photographically safe. Starch paste, animal glue, and rubber cement are not advised. One of the safest methods is mounting prints on album pages with special dry-mounting tissue. Ask your photo dealer for specific recommendations.

You'll want to find a safe home for negatives and extra prints. The envelopes provided by most photofinishers are suitable for storing prints and negatives because they contain no contaminants that would ruin the images. Other containers may have ingredients that will quickly harm photos. The same applies to furniture drawers, attics, and basements where fumes from mothballs, cosmetics, chemicals, glues, or wood-finishing products can cause damaging chemical reactions.

Don't store prints and negatives under pressure—they may stick together. In fact, if you have real favourites, they should be separated into plastic photo sleeves for safekeeping.

SLIDE SHOWS

Most people who take slides like to see that big bright image up on the screen. Because it's so big, it can be shared with many people at the same time, and modern projection equipment can show many slides in a comparatively short time. On the other hand, everyone nods in sympathy when a friend mentions that three of last evening's hours were devoted to someone's slide show or home movies. With a little planning and restraint, you can have your audiences clamouring for more.

First, arrange your slides so that they tell a story, even if it's a simple chronological story of holiday travel. You'll find that narration is easier when you can proceed logically from one topic to the next. Second, use only your best slides. Pass over pictures that are fuzzy or incorrectly exposed. Resist the temptation to show everything. Third, don't leave any one slide on the screen too long – 10 seconds is a

Selecting pictures

Choose only your best pictures ones that are sharp and correctly exposed. Poor-quality pictures are tiring to view and lower the impact of your show. One easy way to look at slides is with the help of an inexpensive illuminator, available from most photo dealers. Project your final choices to check their sharpness.

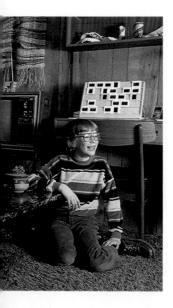

useful average time. If you have to spend a long time explaining a picture, chances are that it's not a very good illustration. Your audience is used to TV and movies where things generally happen pretty fast. Fourth, consider one hour the maximum time that people can sit still comfortably. Fifth, rehearse your presentation a few times, so that you're familiar with the order of the slides and so that your narration will flow easily. Sixth, get everything—screen, projector, and chairs—set up in advance. And make sure that you have a spare projector bulb and know how to change it.

Telling a Story

The easiest way to tell a story with pictures is to put them in chronological order. Since every story has certain key elements or events, use the pictures that best portray the highpoints. You don't have to explain or show every step. Just include the necessary pictures. Too many will dilute the message.

1. Getting ready.

2. Icing the cake.

3. Making the presentation.

PHOTO REPORTS

There are times when photos are more striking than words alone. Reports for business, school, and even your community are more effective when amplified by pictures. You can create a slide show or illustrate a written report with captioned prints, or consider enlargement displays in public places. Here's what's important. The pictures should clearly show exactly what you want them to show. Use no more than you need—too many dilute impact. Make sure that the technical quality is good—sharp and well-exposed pictures. Captions or narration should be short and to the point.

SHOWING PICTURES

PHOTO INVENTORY

Nobody likes to face the idea of calamity, but that's why insurance companies exist. In case of a loss, it's helpful to provide as much evidence as possible. Pictures can be a valuable resource.

Take a moment to make a mental inventory of your possessions and how much it would cost to replace them. With this incentive, you might want to load and use your camera. A series of photographs can effectively document your goods, particularly when combined with the sales receipts.

Start with your home—the outside and the inside. Take pictures outside when the scene is bright and when important features aren't hidden in shadow. Shoot from all important viewpoints, and maybe a few more for extra precaution. When inside, take pictures of the four walls in each room with flash or existing light. (Don't forget to include some of the floor with costly rugs or carpet.)

Once you have covered all the exterior and interior features of the house, begin recording from a closer distance the smaller items such as silverware, fine china, paintings, objets d'art, clothes, tools, small appliances, sports equipment, antique furniture, and jewellery. The same applies to lawn and garden equipment, outside furniture, and so on.

Keep the prints and negatives or slides at your bank in case you ever need them to prove a loss to the insurance company.

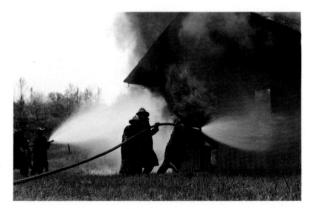

HAS IT HAPPENED TO YOU?

Sometimes things go wrong, and you get results you didn't plan or want. Here are some of the most common problems, the reasons, and some suggested solutions.

Problem	Reason	Solution	
Fuzzy, unsharp pictures	Shutter speed too slow.	For pictures of still subjects, use a shutter speed no slower than 1/30 second if handholding the camera. For fast- moving subjects, use the fastest shutter speed possible—usually no slower than 1/250 second. (See page 141.)	Cam
	Incorrect handling.	Make sure you hold the camera very steady and gently press the shutter release. (See page 44.)	1
	Incorrect focus.	Make sure you focus correctly on your subject. Refer to your camera manual. (See page 45.)	Out
	Dirty lens.	Keep your lens clean of dust and smears. (See page 186.)	

a movement

focus

Dirty lens

HAS IT HAPPENED?

Problem	Reason	Solution
Pictures too light, too dark	Incorrect film speed setting on camera or on handheld meter.	Set or check the film speed every time you load a new roll of film. (See page 36.)
	Dead or weak meter battery.	Check battery periodically according to camera instruc- tion manual. Replace at least once a year.
	No adjustment for side- and back-lighting.	See page 142 for information about adjusting for different lighting angles.
Pictures occa- sionally too light	Shutter may be sticking.	See competent camera repair person.
Blank nega- tives (no	Shutter does not open.	See camera repair person.
prints) or black slides	Film does not advance through camera.	Check loading procedures in instruction manual or have repair person check film- advance mechanism.
	Lens cap not removed.	Make sure you remove lens cap.
Pictures consistently too light or dark	Exposure meter may need adjustment.	See repair person.

.

Too dark

			-
Problem	Reason	Solution	, 8 ^{me} 4
Flash pictures too light, dark	Light—too close to subject. Dark—too far from subject.	Check snapshot camera distance range or check focus setting with adjustable/auto- matic camera. (See page 153.)	
	Film speed on camera/flash unit wrong.	Check to see that correct film speed is set on flash unit or camera. (See page 154.)	
	Aperture setting wrong.	Make sure that aperture setting on camera agrees with information on flash calcu- lator dial. (See pages 155-156.)	Too dark
Flash too dark	Dark-elec- tronic flash may not have fully recycled.	Allow flash to recycle fully until ready light shows or maybe a bit longer.	
	Weak batteries.	(See page 157.) Change batteries.	
People or animals with glowing eyes	Flash posi- tioned too close to lens for subject with dilated pupils.	Turn on all room lights. If possible, remove flash from camera to increase distance between lens and flash. Increase flash-to-subject distance. Have person avert eyes.	Correctly exposed

Too light

HAS IT HAPPENED?

			Construction of the second
Problem	Reason	Solution	
Flash pictures: black slides, blank nega- tives, and no prints	Flash didn't fire.	Battery dead, poor connection between flash and camera. (See page 154.)	
Glare spots in flash pictures	Flash fired into reflective background.	Adjust your posi- tion so that any reflective mate- rial (mirrors, panelled walls, spectacles) is at an angle.	Foreground object
Flash pictures unevenly exposed	Foreground object closer than main subject—gets overexposed.	Use a position where the main subject is closest to the flash.	Object removed
Flash pictures partly exposed	Incorrect shutter speed.	Check your camera manual for correct shutter speed with flash. (See page 154.)	Wrong shutter speed

Reflection from shiny surface

Position changed to avoid reflection

Problem	Reason	Solution	
Pictures with dark obstructions	Finger in front of lens. Mate- rial inside camera.	Check camera- holding position to make sure hand or fingers don't obstruct lens. Carefully check inside camera for foreign matter obstruction.	
	Camera strap or case in front of lens.	Check that lens is clear of strap and case before taking picture.	Finger blocking lens
Pictures with unusual colour	Bluish—tung- sten film used in daylight:	Make sure that the film matches the lighting conditions. If not, add a filter. (See page 168.)	
	Yellowish-red- daylight film used in tung- sten light.	If using daylight film in tungsten light, consider a filter. (See page 168.)	
	Mottled, streaked, maybe greenish or muddy—film outdated.	Make sure you use fresh film and get it processed promptly. Check packing material for expiration date. Do not leave film in extremely hot places.	Tungsten film in dayligh

Daylight film in tungsten light

HAS IT HAPPENED?

Problem	Reason	Solution
Pictures overlapped	Too many pictures on roll.	Don't try to squeeze one more shot at the end of the roll.
	Film winding mechanism needs adjustment.	See a competent repair person.
Light streaks and spots on pictures	Direct rays of light strike lens.	Don't shoot directly into the sun or other bright light source.
Consistent streaks and spots	Fogging: light leak in camera.	Have camera checked by competent repair person.
	Camera back opened accidentally.	Never open the camera without checking to see if it has film inside.
	Film handled in direct sunlight.	Load and unload your camera in the shade or other subdued light.
	Sticking shutter.	Have camera checked by competent repair person.
	X-ray exposure.	Ask for hand inspection of camera and film at airport secu- rity. (See page 89.)

Overlapped pictures

Direct rays of light

Camera back opened

SIMPLIFYING THE TECHNICALITIES

The more you know about any skill or activity, the better the results. This section of *How to Take Good Pictures* is devoted to how photography works and how to extend your knowledge for even better pictures under a greater variety of conditions.

We'll approach our goal—good pictures—in two ways. First we'll take a tour of a typical 35 mm camera to see what functions all the controls perform. We'll look at film to see what makes it work for you. We'll tie film and camera together into a discussion of exposure that will help you get better results in many tricky situations.

Then, after discussing the sketchy fundamentals of how you can control camera and film, we'll talk about some individual techniques that you'll want to sample. Flash, filters, existing light, and more will show you the delight of creation, where *you* control *your* photography.

SIMPLIFYING

CAMERA CONTROLS

All cameras have controls. The simplest camera might have only one control—the shutter release which you press to take a picture.

More complicated cameras may have several controls. Earlier in the book, we gave a short discussion of 35 mm camera operation—enough to help you start. Now we'll take an imaginary automatic 35 mm camera that is fairly complex and describe the function of all the moving parts you need to know about. Your camera may have some or all of the features we'll describe. And very likely some of the devices will be in different positions from those shown here. Compare these diagrams to those in your camera instruction manual.

For greater clarity, we've even repeated some functions. For example, if your camera has a pop-up flash, you probably won't have a flash hot shoe or a flash-cord socket.

Top Front View

- 1. film-advance lever
- 2. film-frame counter
- 3. shutter release
- 4. shutter-speed dial
- 5. flash hot shoe
- 6. rewind knob
- 7. pop-up flash
- 8. pop-up flash button
- 9. viewfinder window
- 10. lens
- 11. aperture ring and mode selector (automatic, manual, possibly flash)
- 12. focusing ring
- 13. film-speed selector dial
- 14. self-timer
- 15. flash-cord socket

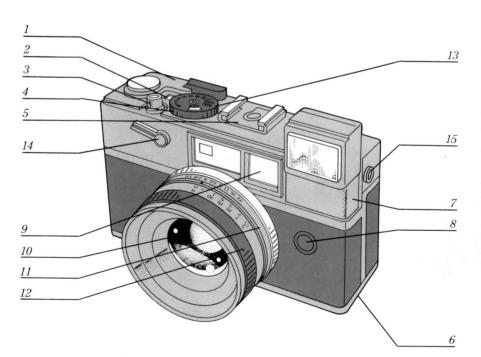

CAMERA CONTROLS

1. Film-advance lever: By moving this lever one or more strokes after taking a picture, you advance the film to the next frame.

2. Film-frame counter: This shows you how many pictures you have taken: from loading steps to 12, 20, 24, or 36.

3. Shutter release: You press this button to take a picture.

4. Shutter-speed dial: This selects the shutter speed. It may include the film-speed selector or the automatic operation switch.

5. Flash hot shoe: This accepts an electronic flash unit. When you attach the flash, the electrical connection is complete.

6. Rewind knob: This knob usually has a foldout lever to help rewind exposed film back into the cassette.

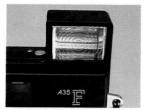

7. **Pop-up flash:** Raise and activate built-in flash with the button shown at figure 8. Turn off the flash by pressing down.

8. **Pop-up flash button:** *This button raises and activates the built-in flash unit.*

9. Viewfinder window: This is the other side of the window you look through to compose your picture.

 Lens: The lens on your camera gathers and organizes light rays to make a sharp picture on your film.

11. Aperture ring: With this you select the lens aperture. The aperture ring may also control automatic, manual, or flash functions.

12. Focusing ring: You turn this to get sharp pictures of your subject. It may show distances as symbols or in feet and metres.

Back View

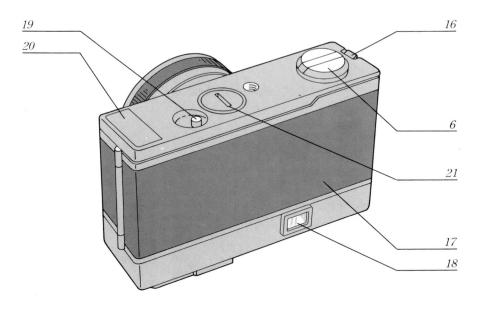

16. release for filmcompartment door17. film-compartment door viewfinder window
 rewind button (film-advance release) 20. pop-up flash battery compartment 21. meter-battery compartment

CAMERA CONTROLS

13. Film-speed selector dial: Every time you load film into your camera, set the film speed on the selector dial.

14. Self-timer: This device automatically snaps the shutter after it is triggered, which allows you to include yourself in the picture.

15. Flash cord socket: Plug the flash cord (PC cord) into this socket to complete the electrical connection between the flash and the camera.

16. Release for filmcompartment door: After you rewind the exposed film, open the compartment door with this latch.

17. Film-compartment door: By operating the latch at figure 16, this door can be opened to load or unload film.

18. Viewfinder window: You look through this window to arrange your picture. You may also see focusing and exposure information.

19. Rewind button (film-advance release): This button releases the filmadvance mechanism so that you can rewind the film.

20. Pop-up flash battery compartment: This compartment holds the batteries that supply the power to your builtin electronic flash.

21. Meter-battery: The battery for automatic or manual cameras with exposure meters should be changed at least once a year.

FILM

Black-and-white negative

Colour negative

Colour slide

In addition to the film information on page 48 here is more information that will help you understand the next section on exposure.

SIZE

Film comes in different sizes and lengths: disc and 110 for pocket-sized cameras, 126 for larger snapshot cameras, and 135 for 35 mm cameras. Films in 110- and 126-sizes generally give a choice of 12 or 24 exposures for colour prints, 20 exposures for colour slides. Film in 135-size cassettes offers several possibilities—12, 24, and 36 exposures for colour prints and 20 and 36 exposures for colour slides.

SLIDES OR PRINTS

Do you want slides to project or prints from negatives to pass around and put in albums? Slides projected on a screen are brilliant and beautiful, but slide film requires near-perfect exposure for good results. Prints are lovely, too, convenient to share, and negative film is somewhat tolerant of exposure error. You can have enlargements made from either.

Bright-low or medium-speed film

Dim-high or very high-speed film

SPEED

All films have a measured sensitivity to light, indicated by an assigned ISO number. Low- and medium-speed films—ISO 25, 32, 64, 100, 125, 200—are intended for general picture-taking in daylight, while high- and very high-speed films— ISO 320, 400, and 1000—are intended for low light. If you take pictures on dark days, indoors, or at night without flash, you'll want a high- or very high-speed film.

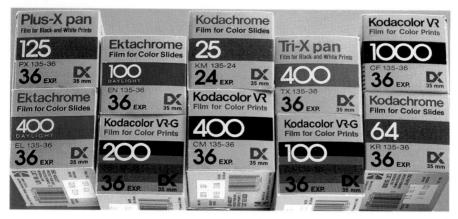

There are other considerations, too. Sharp pictures of action require fast shutter speeds (see the "Exposure" section, pages 138-141).

On the other hand, there's a good reason for choosing a slower, less sensitive film. With careful examination, prints or slides from high-speed films don't appear quite as sharp as those from the slower films. This is especially true for enlargements. For scenic pictures you may decide that it's important to have as sharp an image as possible from a film with a speed of ISO 25, perhaps.

Choosing a film speed is often a function of what's most important—extreme speed or extreme sharpness. If you don't need the extremes, stick to one of the medium-speed films, ISO 64 to ISO 125, which will be very sharp and still allow you enough speed for moderately fast action or a fairly wide range of lighting conditions.

COLOUR BALANCE

Most films give natural-appearing colours in daylight or with flash. Some negative films respond almost as well to tungsten or fluorescent light. If you want correct colour rendition in lighting other than daylight, choose a film balanced for a particular light source, or use colour-correction filters. (See page 169 in the "Filters" section.)

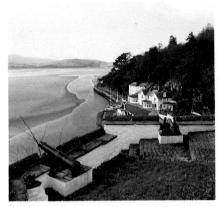

Daylight-daylight film

Daylight-tungsten film

"When all else fails, read the instructions." Actually, the film data inside the box or on a sheet can be very helpful if your meter fails. Some of the information may even prove to be valuable casual reading.

FILM INSTRUCTIONS

Some of the handiest information around is in the instructions packaged with some films for automatic and adjustable cameras. You'll find data on exposure, flash, and filters. If your exposure meter fails, consult the instructions. If puzzled about filtration, see the inside of the box.

CARE

All film has a useful life. Usually there's an expiration date printed on the film box. Take pictures and have the film processed before that date.

Extremes in humidity and temperature are film's worst enemies. In heat and high humidity, protect your film and camera as well as you can. For instance, don't store them in the attic or basement. Don't leave them in direct sunlight, the glove compartment of your car, or a similar high-temperature environment. When taking pictures in cold dry air, keep your camera and film close to your body so that cold film won't get brittle and snap when it is advanced or rewound. Keeping your camera warm will also help prevent static electricity marks on your film.

Try to change film in the shade, even if it's the shade of your own body to help eliminate fog marks on your film from direct, bright sunlight.

EXPOSURE

Although automatic cameras successfully choose exposure settings without human help, understanding the rudiments of exposure can improve your picture-taking. There are four factors—scene brightness, film sensitivity, shutter speed, and aperture.

SCENE BRIGHTNESS

Scene brightness can vary widely, from a sunny day at a beach with white sand to a somber plaza lit only by a shaded street light. To record these extremes and all the variations in between, your photographic apparatus must be flexible

FILM SENSITIVITY

As discussed on pages 133-134, film comes in a wide range of sensitivities, or speeds, for a wide range of lighting conditions and applications. Film speed helps determine camera exposure settings. Once you match the film to the situation, an ISO 100 film for fair weather for instance, then you or the camera must adjust the shutter speed and aperture.

Extremely dim light. High speed film (ISO 400–1000) would be a must in this case.

Bright light. A slow- or medium-speed film (ISO 25–200) would work well here.

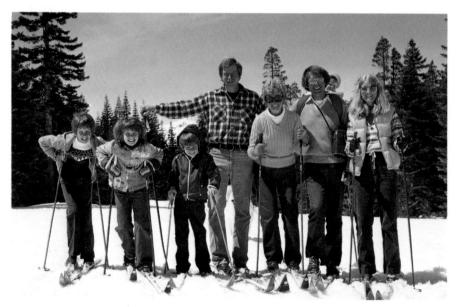

SHUTTER SPEED

The shutter speed controls the *length of time* that the shutter stays open. The longer the shutter is open, the more light it lets in. When open, it's usually for a very brief time, anywhere from 1/1000 second to 1/30 second. You can see the different speeds on your camera's shutter speed control: 1000 (1/1000), 500, 250, 125, 60, 30, and sometimes 15, 8, 4, 2 (1/2), and 1 second. The B setting is used to make time exposures. Each shutter speed is roughly half or double its immediate neighbour. The shutter will let in half as much light at 1/125 as it will at 1/60 second, but twice as much as if set at 1/250. (Older cameras may have slightly different shutter speeds, such as 500, 200, 100, 50, 25, 15, 10, 5, 2, 1. There's no cause for concern. Operation is exactly the same as with newer values. It might be helpful, however, to have the shutter speeds on an older camera checked for accuracy.)

Changing the aperture or the shutter speed will change the amount of light that reaches the film. Automatic cameras will compensate for the gain or loss in light. The picture series at right shows the effect of one-stop changes in the aberture setting. Changing the shutter speed would have produced the same results. Most people would consider the image at lower left to be correctly exposed.

APERTURE

The aperture controls the *amount* of light you let into the camera. The aperture on most automatic cameras is adjustable from a large opening, f/2.8, to a small opening, f/22. Contrary to what you'd expect, the *smaller the number, the bigger the aperture*. The *f*-number represents a ratio between the size of the aperture and the focal length of the lens. f/11 would mean that the aperture diameter is 1/11 the focal length of the lens. Customary aperture numbers are f/22, f/16, f/11, f/8, f/5.6, f/4, f/2.8, f/2 and occasionally f/1.8, f/1.7, or f/1.4.

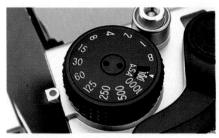

Shutter speed dial

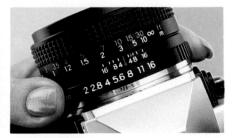

Aperture ring

EXPOSURE

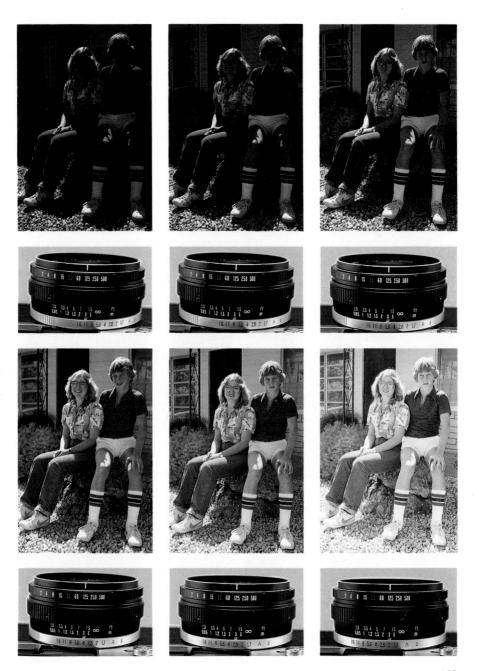

SHUTTER SPEED PLUS APERTURE

The *f*-numbers work in one sense the same way as shutter speeds. An aperture set at f/2.8 lets in twice as much light as its neighbour on the scale, f/4, but only half as much as its neighbour on the other side, f/2. The big surprise is that the unit spacing for shutter speeds and *f*-numbers is comparable. A change from one shutter speed to the next gives the same exposure result as changing from one f-number to the next. This means that several different combinations of *f*-number and shutter speed will give good exposure under the same lighting conditions with the same film. For instance, if you set aperture and shutter speed at f/8and 1/125, respectively, you can get the same exposure as if you had set f/5.6 and 1/250. f/4 and 1/500, f/2.8 and 1/1000, f/11 and 1/60, f/16 and 1/30, or *f*/22 and 1/15-second.

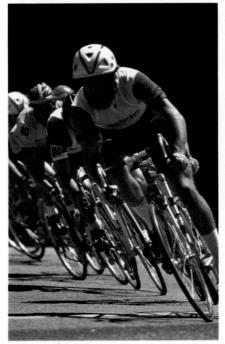

Fast shutter speed

Slow shutter speed

Large aperture

Small aperture

What's the reason for all the numbers? If you think back a second, you'll realize that you need the extensive adjustments to cope with all the possibilities in lighting that you're likely to come across. There are other reasons as well. Fast shutter speeds such as 1/250, 1/500, and 1/1000 will stop rapid action. Slow shutter speeds such as 1/30, 1/15, and 1/8 second are often used intentionally to blur certain action subjects into a swirl of colour and motion. Moderate shutter speeds are used for general photography—fast enough to arrest hand movement, but slow enough to permit middle-size apertures and medium-speed film.

On the other hand, changing the aperture changes the depth of field (explained in detail on pages 144-145). Large apertures such as f/2.8 and f/2 give a shallow depth of field where only your subject, or part of your subject, is in sharp focus. Small apertures such as f/16 and f/22 give great depth of field. Experienced photographers use all these controls—film speed, shutter speed, and aperture size—to keep as much control over the resulting picture as possible.

EXPOSURE METERS

Getting the right exposure for a given situation is often a matter of opinion. Some photographers prefer their slides a little darker than others. Generally, though, acceptable exposure will still show some detail in the brightest areas and some in the darkest.

Most people use manually adjustable cameras with built-in exposure meters or automatic cameras in which a built-in meter sets the shutter speed, the aperture, or both. In any case, the meter will gather the exposure information for you. Always take a reading very close to the subject before stepping back and composing the picture. Check your camera or exposure meter instruction manual for information on its operation.⁴

There are times when a camera exposure meter will not make the right exposure decision. What you must do is recognize the situation and compensate. Here are typical situations and compensations:

Sidelit subject	increase exposure 1/2 stop
Backlit subject	increase exposure 1 stop
Small bright subject against dark background	decrease exposure 1 stop
Small dark subject against bright background	increase exposure 1 stop
Average subject extremely bright scene, such as snow or sand	increase exposure 1 stop

Although camera exposure meters take much of the work out of determining and setting exposure, they often miss in the situations described at left. With an adjustable camera that has a built-in meter, make your meter reading, and then adjust as recommended at left.

On some automatic cameras, there is a way to override manually the automatic exposure feature. It may be a dial that offers up to a two-stop increase or decrease in exposure. It may also be a way to switch the camera to completely manual operation.

Other cameras are entirely automatic with no apparent way to alter the camera-selected settings. To increase the exposure by one stop, set the film-speed indicator to a value half of the speed of the film you're using. To increase exposure by two stops, cut the film speed to one quarter of the real value of the film in the camera. The reverse is true for decreasing exposure. Double the film speed setting for a one-stop decrease in exposure and quadruple it for a two-stop decrease. DO NOT FOR-GET TO RETURN THE FILM-SPEED SETTING TO THE COR-RECT VALUE AFTER YOU'VE MADE YOUR SPECIAL-SITUA-TION PICTURE.

Meter recommendation

Decrease exposure one stop

Increase exposure one stop

Meter recommendation

- 1. Use medium-speed film in normal outdoor situations, high- or very high-speed film in dim scenes, and low-speed film for the sharpest pictures possible.
- 2. Use a shutter speed at least as fast as 1/125 second for most situations to prevent camera movement from blurring your picture.
- 3. Fast shutter speeds capture action; slow shutter speeds blur action.
- 4. Large apertures give shallow depth of field; small apertures give great depth of field.
- 5. Usually several combinations of shutter speed and aperture will give correct exposure. Review

the reasons for choosing shutter speeds and apertures.

- 6. Check the manual for your exposure meter or automatic camera to compensate for very bright and very dark subjects.
- Sidelighting and backlighting often require more exposure than frontlighting—one half and one stop, respectively.

Note: If the film speed selector on your camera cannot register a very high-speed film such as ISO 1000, compensate by setting it to 500 for this instance and using the next faster shutter speed or the next smaller aperture.

DEPTH OF FIELD

Shallow depth of field -f/2

Great depth of field-f/22

When you focus your camera lens on a subject, you are unknowingly including a greater area in focus. Each aperture setting gives a different depth of field—that is, the distance range that is in acceptably sharp focus. Small apertures such as f/11, f/16, and f/22 give the greatest depth of field, while large apertures such as f/2.8, f/2, and f/1.4 give very little depth of field.

Many single-lens-reflex cameras incorporate a previewer that shows how much of the scene is sharp at different apertures. Other cameras usually include a depth-of-field scale that surrounds the distance scale on the lens barrel. By looking at the indicators for the *f*/number you are using, you can see how much of the scene will be sharp in front of and behind the subject.

Depth of field also depends on the camera-tosubject distance. With the same aperture, depth of field will be shallower if you focus on a nearby object than if you focus on a distant one.

You can include more foreground than background by focusing closer than your main subject but still keeping the subject within the depth of field. The reverse is also true.

You can use your understanding of depth of field to preset your camera in a fast-action situation so that you won't have to refocus as the activity gets close and then recedes. Set the smallest aperture your action shutter speed will allow and then focus on the spot where most of the action will take place. Even if things drift back and forth a little, your pictures will still be in focus.

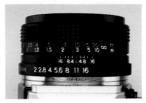

By aligning the indicators for the aperture setting (f-number) on the depthof-field scale with the distances on the focusing ring, you can see the range that will be in sharp focus. The aperture above is f/11. The indicators-between 16 and 8 on the depth-of-field scale-show that anything at a distance between about 2 and 5 metres from the camera will be in acceptably sharp focus.

DEPTH OF FIELD

With a small aperture and preset focus, you can concentrate on the action.

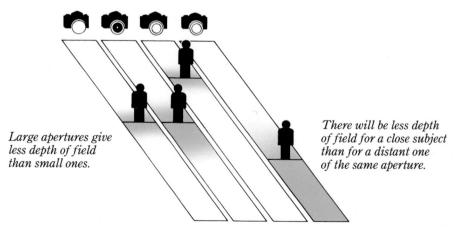

LIGHTING

Light is the basis for all picture-taking. Light in the morning is a striking change from light at noon. Bright days are vastly different from cloudy days. Shady spots, open fields, and home interiors, summer, autumn, winter, and spring all have their unique light properties—all somehow adaptable for good pictures. Let's first discuss the angles of light that apply for almost any situation.

ANGLES OF LIGHT

There are three basic lighting angles—frontlighting, sidelighting, and backlighting. Frontlighting means that light is coming from behind the photographer, brightening the side of the subject facing the photographer. A sidelit subject has light striking one side, and backlighting illuminates the side of the subject away from the photographer. Frontlighting is common for most picture-taking, but it may not give the most effec-

Frontlighting

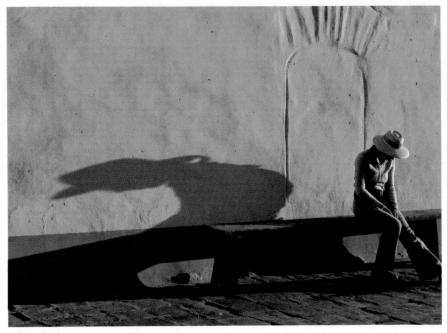

Sidelighting

tive photos. People tend to squint when looking into the sun and dark shadows surround their eyes. Frontlighting is also flat, giving few shadows that help create a feeling of perspective.

Sidelighting is more dramatic, with shadows streaking across the picture, helping to establish shape and three-dimensionality. Sidelighting can also give portraits increased impact. Many photographers prefer backlighting for close-up pictures of people, because their subjects never have to look near the sun. Expressions are relaxed and natural and there are no contrasting shadow and lighted areas. Backlighting may also give striking scenic pictures, especially early or late in the day, with long shadows racing back toward the camera from rich, black silhouettes. Sidelighting and backlighting require exposure adjustments for properly exposed subjects (not silhouettes). See pages 142-143 in "Exposure" for more information.

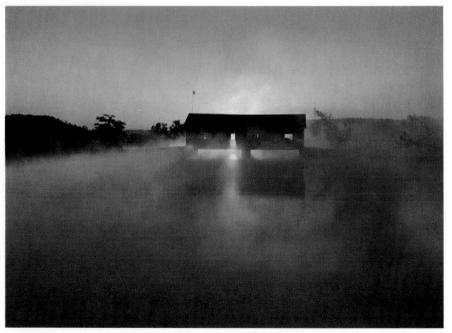

Backlighting

IN THE SUN OR OUT

You also have a choice between photographing a subject in bright sunlight or in shade. It depends on the subject. If you want hard, black shadows, photograph in sunlight. If you want a softer quality of light (although a little cooler-coloured) take your subject into a shady spot that's clear overhead. There will be plenty of light, but no harshness.

Light overcast days are excellent for some picture-taking. If you have diffused sunlight that creates soft shadows, you have perfect lighting for a portrait.

COPING WITH SUNLIGHT

Sunlight gives shadows. You can reduce the intensity of these shadows by using a crinkled foil or white reflector to bounce light back at the subject. Experiment by angling a white or foil-covered piece of cardboard in different directions to see how much reflection you want.

You can also use light from a flash device to fill in shadows. (See page 160 in "Flash" for more information.)

DIFFERENT TIMES OF DAY

The colour and intensity of sunlight changes throughout the day. Early morning photographers (dawn to 9 a.m.) are rewarded with a soft, pale, sometimes rosy light, painting long shadows that

Bright sun

Overcast

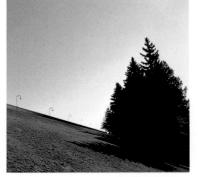

9AM

Noon

are freshened by dew. It's beautiful light for landscapes, especially if you find a few patches of lowlying ground fog. People benefit from this light, too. From 10 a.m. to 4 p.m., sunlight is brilliant and harsh, dropping small, dense shadows. Ordinarily it's not very attractive unless that's the mood you want. From 4 p.m. to sunset, the light deepens in warm tones and lavishly smooths rich shadows across the land. It's dramatic lighting for sidelit landscapes and sometimes even people. Between sunset and complete darkness comes perfect lighting and colour for existing-light cityscapes. (See pages 162-165.)

INTENSITY

Although our eyes don't see it, there's a vast difference in the intensity of light as it changes. A shaded spot is much darker than a sunlit area, as is any scene on a cloudy day. Indoors, it's *much* darker than outdoors. (See page 165 in "Existing Light" for more information.) Make sure that you or your camera make the adjustments necessary for changing lighting conditions. (See pages 136-143, "Exposure," and page 133, "Film," for more information about scene brightness.)

Light gives our pictures a chance to appear. It is endlessly variable, and if you study its effects, you'll be able to apply your knowledge to making better pictures in any situation.

Without reflector

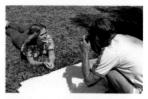

Bedsheet reflector

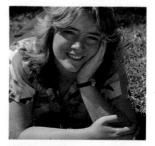

With reflector

4 PM

Sunset

SEASONS

As the seasons change, so does the nature of light. Have you ever noticed how much stronger midsummer light is than spring or winter light? Remember those crisp autumn days when the edges of every leaf seem to snap out towards you? Indeed, the lighting is different. Winter with snow finds the sun at a low angle casting weak shadows. reflecting off snow and ice everywhere. Your meter may be fooled by all the whiteness into recommending underexposure. For snow scenes, increase your exposure one stop (see page 142 in "Exposure") over the meter reading. Springtime also brings weakened sunlight, not reinforced by snow reflections. It's beautiful light for people and other subjects not flattered by strong contrast between shadow and light areas. The sun in summer seems to beat down with a vengeance, almost too strong for most picture-taking. By carefully watching the angles and time of day, you can take endless, excellent pictures in summertime, when all the world comes out to play. Clear, strong (but not overpowering) sunlight characterizes autumn. Brilliant for landscapes, it can also give lovely shade-lit portraits.

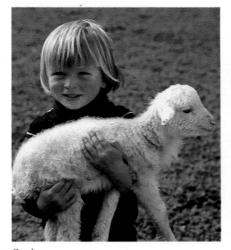

Summer

Spring 150

LIGHTING

Winter

FLASH

When it's too dark to take pictures, the logical decision is to use flash. Some cameras even tell you when it's necessary. There is nothing tricky about flash photography, provided you know the basics and understand your equipment.

GENERAL TIPS

Reflections Watch out for reflective backgrounds or spectacles in the scene. If you take a flash picture directly at either, you'll get an unattractive glare spot in your picture. Stand at an angle to mirrors, windows, or shiny panelling. Ask subjects wearing glasses to turn their heads slightly or remove their glasses.

Red Reflections Some people's eyes (and some pets') can reflect flash with an eerie, often red glow. To prevent this internal reflection of the flash, turn on all the room lights—the extra brightness will help reduce the size of the iris. Then, if possible, increase the distance between flash and camera

Reflection in glass

Change position.

Overexposed foreground

Foreground objects removed

lens. Some cameras will accept a flash extender. Finally, back off to a point within the flash range where the reflections will be less noticeable.

Flash Range With snapshot cameras, photograph subjects within the flash range recommended for your camera, flash type, and film. With other cameras, the range for good flash exposure is determined by the film speed, the aperture setting, and possibly the flash mode.

Overexposed Foreground Any person or object closer than the minimum limit of the flash range will be overexposed and too bright in your flash picture. Compose the scene so that the main subject is closer than anything else, but still within the flash range.

Several Subjects Subjects at different distances from the camera will receive different amounts of flash light—some will be too bright or too dark. Make sure that all your subjects are roughly the same distance from the flash.

Subjects scattered at different distances.

Subjects grouped at same distance.

SNAPSHOT CAMERAS

To get well-exposed pictures with your snapshot camera, keep your subject in the correct flash distance range—usually 1.2 to 3 metres with flashcubes, use fresh batteries, and keep the camerabattery contacts clean. With flashcubes, magicubes, or flipflash, check to see that an unused bulb is in position before making an exposure. If you have an add-on or built-in electronic flash unit, see the general information below.

ELECTRONIC FLASH

The most popular flash accessory for 35 mm cameras is the electronic flash unit. Different systems are detailed in the following pages. Before searching for your flash and camera combination, read the general tips below.

- On a camera with built-in flash, make sure that the film-speed setting is correct for good exposure. Set your film speed on a separate flash unit.
- 2. If necessary, set the shutter speed recommended by your camera manual for electronic flash. Because the flash duration is typically 1/1000 or less, shutter speed does not affect exposure. If set too fast, however, you'll get partly exposed pictures with a focal-plane shutter or underexposed pictures with a leaf shutter.
- 3. Focus carefully. Camera-to-subject distance determines exposure with built-in flash.
- 4. Cameras that don't have built-in flash have an accessory shoe that may be electrically sensitive—a hot shoe. Slide a flash unit with a matching hot foot into the shoe to make the necessary connection. Older cameras or flash units may not be hot. Plug the cord (PC cord) that usually comes with the flash unit into flash and camera. If there is a choice of camera sockets, choose the one marked X—the other is for flashbulbs.
- 5. Flash units take a few seconds to get ready (recycle) for the next picture. The ready light will glow when the flash is ready. When the ready light takes a long time to glow, change the batteries or recharge the flash unit.

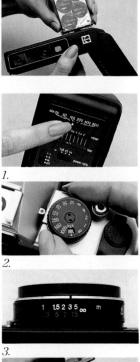

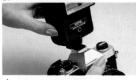

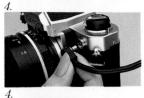

BUILT-IN AND DEDICATED AUTOMATIC

Some 35 mm cameras have a built-in flash unit or can be matched with a special flash unit—a "dedicated" system. Turn on the flash, focus, and take a picture. The camera and flash combination makes exposure settings automatically. Cameras with built-in flash rely on the film speed set on the camera. Separate flash units may need to have the film speed set on a dial.

Other cameras work automatically with any flash, provided that you follow instructions and preset any necessary adjustments, such as flash mode switch or the guide number. (See page 157.) It's necessary to set the focus carefully for sharp pictures *and* for correct exposure. (Focusing also controls the aperture.)

SENSOR-CONTROLLED AUTOMATIC

Automatic flash units designed to work with any camera are governed by light sensors. When you set the film speed on the flash, and select an aperture and a corresponding flash mode, the sensor will govern how much light the flash emits by measuring the intensity of light reflected by the subject. For each aperture and mode combination, the sensor will be able to control flash output over a certain distance range. Read the instruction manual carefully for correct operation of sensor-controlled automatic flash units.

With a sensor-automatic flash unit, you decide what distance range you'll need, choose the appropriate flash mode, and set the aperture. The flash will do the rest to give good exposure. Make sure you set the film speed on the flash unit. The unit pictured is set at its yellow mode which gives a range of 1.6 to 8.5 feet with an ISO 100 film at f/8.

Press a button to raise and activate the flash.

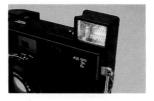

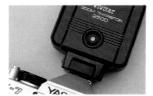

The sensor inside the circle governs flash output.

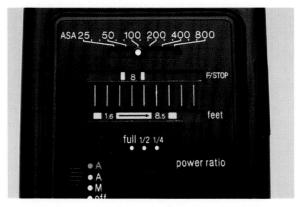

MANUAL FLASH UNITS, MANUAL OR AUTOMATIC CAMERAS

Older or inexpensive flash units operate at full power for every picture. You have to adjust the camera for correctly exposed flash pictures. Since the shutter speed will always be the same (as recommended by the camera instruction manual usually 1/30, 1/60, or 1/125 second) you have to set the aperture. Here's a typical operation given in a step-by-step sequence.

- 1. Attach the flash unit to the camera. If the camera does not have a hot shoe, connect the camera and the flash with a PC connecting cord.*
- 2. Set the ISO speed of the film you're using on the calculator of the flash unit.
- 3. Set the correct flash shutter speed on the camera.
- 4. Turn on the flash unit.
- 5. Focus on your subject.
- 6. Check the lens distance scale for the distance between flash and subject, assuming that the flash is attached to the camera. (Exposure is always based on the distance between *flash* and *subject*—not camera and subject.)
- 7. Apply the distance to the flash unit calculator to find the correct aperture.
- 8. Set the aperture on the camera.
- 9. Take the picture.

The process usually takes only a few seconds. Many people preset their cameras at 3 metres, particularly at parties and take pictures from that distance only.

*Older cameras may require you to choose a socket for the PC cord or select a synchronization setting. If faced with a choice of sockets, plug the cord into the socket marked X for electronic flash. The other socket is for a flash-bulb unit. Set a synchronizing switch at X as well. Check your camera manual for additional flash synchronization instructions.

Note: If the film-speed dial won't register the 1000-speed film you're using, set it to 500 and select a lens opening one stop smaller than indicated.

GUIDE NUMBERS

The proliferation of automatic flash systems has nearly erased the memory of a formula used to calculate aperture settings for flash pictures. It may be handy in a pinch.

It works like this. If you know the guide number for your flash unit/film combination, you can easily set the aperture when you know the flash-subject distance. Merely divide the guide number by the distance—the resulting number is the aperture, or very close to it. See the example below.

Guide Number Formula The guide number of the flash unit is 20 with ISO 100 film. Flash-to-subject distance is 2.5 metres.

 $20 \div 2.5 = f/8$ (round when necessary)

Often the guide number for a particular unit is given for only one film speed. Do the same calculations but add or subtract f-stops as indicated by the decrease or increase of speed in the film you're using. (If you're using ISO 100 film and switch to ISO 200 film, perform your usual guide number calculation and then select the next smaller f-stop.)

If you need the guide number for a flash unit that has an exposure calculator, set the film speed, and read the guide number across from the 10-foot distance indicator. The guide number changes for different film speeds.

CARE AND HANDLING

An electronic flash unit's worst enemies are weak batteries and infrequency of use. Particularly with rechargeable models that use nickel-cadmium cells, try to take a few flash pictures every month. Better yet, remove and store batteries in the freezer to preserve their life and protect the flash unit's contacts. Remove the batteries with the power on and the capacitor fully charged to protect the flash unit during storage. Before taking pictures after storage, allow frozen batteries several hours of thawing time to reach room temperature. Then, put them in the unit and form the capacitor by firing the flash manually several times. Remember that weak batteries can shorten the life of your flash unit, and it should enjoy a long life.

Replace batteries as recommended. Extend their useful life by occasionally cleaning the contacts with a pencil eraser.

FLASH OFF CAMERA

Moving the flash off the camera flatters many subjects. The lighting gives enough shadow for a three-dimensional appearance.

Removing the flash from the camera may defeat the automatic function of a dedicated flash system. If so, determine exposure by using the manual method described on page 156. Most sensor-

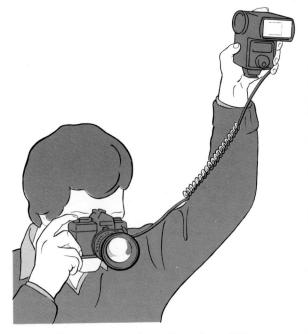

operated automatic units will perform if the sensor is aimed at the subject, and certainly most manual units will work. All you need is an extension PC cord to connect camera and flash. Remember that *flash-to-subject distance* determines aperture setting. It won't be very different if you hold the unit at arm's length. But if a friend or family member holds the flash unit at a distance different from the camera-subject distance, make your exposure adjustments based on *flash-to-subject* distance.

Flash on camera

Flash off camera

BOUNCE FLASH

Bouncing the flash off the ceiling or a nearby wall is another way to improve your subject's appearance. The indirect light is softer, less harsh, and often the soft shadows can help you create a feeling of three-dimensional form.

Again, the idea and execution are fairly simple. Some sensor-governed automatic units will work correctly, provided that the sensor is aimed at your subject. If this is impossible, operate the unit manually, as you will have to do with some

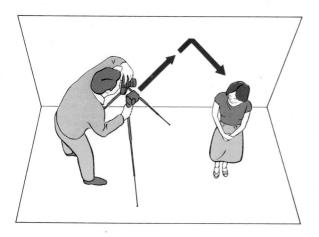

dedicated automatic flash units or a manual unit. Here's how.

Choose a location near a white or light-neutral coloured wall or ceiling. The wall may be preferable because it won't cast shadows under a person's eyes. Calculate the distance that the light must travel from flash-to-wall-to-subject. Estimate the aperture necessary for that distance and then open up the aperture an additional two *f*-stops. For instance, let's say that the distance is 4.5 metres (2 metres from flash to wall and 2.5 metres back to the subject) and your flash calculator recommends an aperture of f/5.6. Instead of f/5.6, set f/2.8 on the aperture ring.

Your wall and ceiling situations are unique. It's a wise idea to experiment a little with slide film and keep records to fine tune your exposure.

Direct flash

Bounce flash

FILL-IN FLASH

One way to reduce the contrast of shadow and lighted areas in bright sunlight is to fill those shadows with light from an electronic flash unit. (The results may also be satisfactory with a snapshot camera. Try it and see.)

Manual and Sensor-Governed Units The idea is to add a hint of light to a subject in frontlighting, sidelighting, backlighting, or even in the shade. Too much flash light may make your picture appear artificial. Follow these simple guidelines for most manual and sensor-governed automatic flash units.

- 1. Set the shutter speed recommended for flash photography. Set the aperture for the prevailing lighting conditions with that shutter speed.
- 2. Set the calculator on your manual or sensorgoverned automatic flash unit to a number two or three times as great as the speed of the film you're using. This way the flash will not overpower existing-lighting conditions.
- 3. Locate yourself and your subject at the distance recommended on the flash calculator for the aperture already set on the camera.
- 4. Take a flash picture.

Dedicated Automatic Flash Fill On cameras with built-in flash units, just extend the flash and take a picture. There isn't much you can control. Try taping a layer of white tissue over the flash to soften the light. Because cameras that have matched, separate flash units vary in their approach to fill-in flash, read the instructions for your outfit carefully. Make sure you don't cover the sensor with tissue.

With some KODAK VR 35 Cameras, you can use the "fill-flash" feature. Just slide in and hold the fill-flash switch during picture-taking. This prevents underexposure of the main subject, caused by a bright, surrounding area that fools the camera sensor.

Flash is a useful tool that will serve you in many more ways than merely brightening dark interiors. Fill-in flash will brighten the shaded side of a subject outdoors which allows people to look away from the

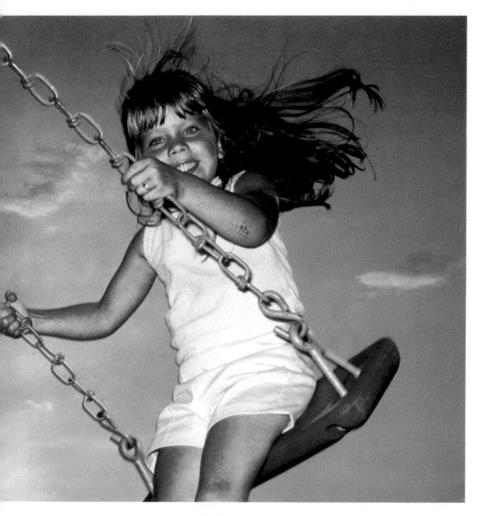

in. They can relax their faces ad eyes from squinting and fer more cheerful, natural pressions. Flash can also op fast action for a picture, in the case of the swinging ild above.

ACTION

The duration of an electronic flash is usually much shorter than your fastest shutter speed. This highspeed capability can stop even very fast action in dark places—children playing, pets jumping, Ping-Pong players smashing, and so on. Exposure is based on flash-to-subject distance. Remember that bounce flash provides more natural light.

EXISTING LIGHT

Taking pictures by existing light means picturetaking in dim lighting without flash. You need high-speed film (ISO 400 to ISO 1000) and a lens with an f/2.8 maximum aperture or larger. Read the following pointers and have a look at the exposure suggestions on page 165.

Take exposure meter readings as close to your subject as possible. Avoid reading parts of the scene that include a bright light source, such as this candle. The small spot of bright light may confuse your exposure meter into recommending underexposure.

SOME POINTERS

- 1. Don't include a bright light source when making a meter reading. The light will fool your meter into recommending underexposure.
- 2. Make meter readings close to your subject.
- 3. With an automatic camera, get as close as possible to your subject to take the picture.
- 4. The side of your subject facing the light should probably be the one you photograph.
- 5. Since your shutter speeds may be fairly slow-often at 1/30 second-hold your camera steady.
- 6. If you use a shutter speed slower than 1/30 second, brace your camera against something solid or mount it on a tripod.
- 7. Try to match your film to the scene lighting. Using filters reduces the light available.

- 8. KODAK EKTACHROME Films can be push-processed one additional stop by your photofinisher. If you're using an ISO 400 film, set the film speed dial at ISO 800 when you ask for special (push) processing. Expose the whole roll at the same film speed.
- 9. A wide range of exposures may be acceptable in many existinglight situations. Experiment with different exposures to see what you prefer.
- 10. At the very large apertures you'll be using (f/2.8 or f/2), depth of field is very shallow. (See pages 144-145 for more on depth of field.) Be sure to focus carefully.
- 11. Consult the "Suggested Exposures" table on page 165.

Many existing-light scenes can be captured with a wide range of exposures, as you see in these views of Niagara Falls. It's wise, in fact, to take several pictures at different exposure settings, so that you'll have several to choose from. Left: 2 seconds at f/4. Top left: 4 seconds at f/4. Top right: 8 seconds at f/4. For this type of scene, you might want to use KODACOLOR VR 1000 Film.

Suggested Exposures Consider the exposure settings shown in the table at right as guidelines. It's wise to bracket your exposures, especially with slide film, because many existing-light scenes can fool an automatic camera or built-in exposure meter. Typical existing-light subjects may be acceptable in a wide range of exposures, especially outdoors at night.

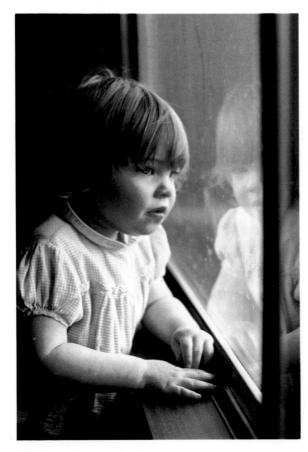

For colour slides, use tungsten film. You can use daylight film, but your şlides will look yellow-red.

- For colour slides, use daylight film or tungsten film with No. 85B filter and 1 stop more exposure.
- For colour slides, use either daylight or tungsten film.

For colour prints you can use KODACOLOR films for all the scenes listed.

In a window-light portrait like this, you'll probably get best results when you take your exposure reading from the bright side of your subject's face. Emphasize that side when you compose the picture.

Picture Subject	ISO 64-100*	ISO 125-200	ISO 400††	ISO 1000
AT HOME Home interiors at night Areas with bright light Areas with average light	1/15 sec f/2 1/4 sec f/2.8	1/30 sec <i>f</i> /2 1/15 sec <i>f</i> /2	1/30 sec <i>f</i> /2.8 1/30 sec <i>f</i> /2	1/30 sec f/4 1/30 sec f/2.8
Candlelit close-ups	$1/4 \sec f/2$	$1/8 \sec f/2$	$1/15 \sec f/2$	1/30 sec f/2
Indoor and outdoor holiday lighting at night, Christmas trees	$1 \sec f/4$	1 sec f/5.6	$1/15 \sec f/2$	1/30 sec f/2
OUTDOORS AT NIGHT Brightly lit downtown street scenes (Wet streets add interesting reflections.)	1/30 sec <i>f</i> /2	1/30 sec f/2.8	1/60 sec f/2.8	1/60 sec f/4
Brightly lit nightclub or theatre districts—such as Piccadilly Circus	1/30 sec f/2.8	1/30 sec f/4	$1/60 \sec f/4$	1/125 sec f/4
Neon signs and other illuminations	1/30 sec f/4	1/60 sec f/4	1/125 sec f/4	1/125 sec f/5.6
Floodlit buildings, fountains, monuments	1 sec f/4	1/2 sec f/4	1/15 sec f/2	1/30 sec f/2
Skyline—distant view of floodlit buildings at night	4 sec <i>f</i> /2.8	$1 \sec f/2$	1 sec <i>f</i> /2.8	1 sec <i>f</i> /4
Skyline-10 minutes after sunset	1/30 sec f/4	1/60 sec f/4	1/60 sec f/5.6	1/125 sec f/5.6
Fairs, amusement parks	1/15 sec f/2	1/30 sec f/2	1/30 sec f/2.8	1/60 sec f/2.8
Fireworks—displays on the ground	1/30 sec f/2.8	1/30 sec f/4	1/60 sec f/4	1/60 sec f/5.6
Fireworks—aerial displays (Keep shutter open on Bulb for several bursts.)	<i>f</i> /8	<i>f</i> /11	<i>f</i> /16	f/22
Burning buildings, campfires, bonfires	1/30 sec f/2.8	1/30 sec f/4	1/60 sec f/4	1/125 sec f/4
Night football, athletics [†]	1/30 sec f/2.8	1/60 sec f/2.8	1/125 sec f/2.8	1/250 sec f/2.8
Floodlit water and fountains White lights Light-coloured lights Dark-coloured lights	15 sec f/5.6 30 sec f/5.6 30 sec f/4	8 sec f/5.6 15 sec f/5.6 30 sec f/5.6	4 sec f/5.6 8 sec f/5.6 15 sec f/5.6	4 sec f/8 4 sec f/5.6 8 sec f/5.6
INDOORS IN PUBLIC PLACES Basketball, hockey, bowling	1/30 sec f/2	1/60 sec <i>f</i> /2	1/125 sec f/2	1/125 sec f/2.8
Stage shows Average Bright	1/30 sec f/2 1/60 sec f/2.8	1/30 sec f/2.8 1/60 sec f/4	1/60 sec <i>f</i> /2.8 1/125 sec <i>f</i> /4	1/125 sec f/2.8 1/250 sec f/4
Circuses Floodlit acts Spotlit acts (carbon-arc)	1/30 sec <i>f</i> /2 1/60 sec <i>f</i> /2.8	1/30 sec <i>f</i> /2.8 1/125 sec <i>f</i> /2.8	1/60 sec <i>f</i> /2.8 1/250 sec <i>f</i> /2.8	1/125 sec f/2.8 1/250 sec f/4
Ice shows Floodlit acts Spotlit acts (carbon-arc)	1/30 sec <i>f</i> /2.8 1/60 sec <i>f</i> /2.8	1/60 sec f/2.8 1/125 sec f/2.8	1/125 sec <i>f</i> /2.8 1/250 sec <i>f</i> /2.8	1/250 sec f/2.8 1/250 sec f/4
Interiors with bright fluorescent light	1/30 sec f/2.8	1/30 sec f/4	$1/60 \sec f/4$	1/60 sec f/5.6
School-stage and auditorium	_	1/15 sec f/2	$1/30 \sec f/2$	1/30 sec f/2.8
Church interiors-tungsten light	1 sec f/5.6	1/15 sec f/2	$1/30 \sec f/2$	1/30 sec f/2.8
Stained-glass windows, daytime— photographed from inside	Use 3 stops more e:	xposure than for the	outdoor lighting cor	nditions.

Suggested Exposures for Existing-Light Pictures

*With ISO 25-32 film, increase exposure by 2 stops.

†When lighting is provided by tungsten lamps and you want colour slides, use tungsten films. **If your camera doesn't have this lens opening, use the next larger opening.

t†KODAK EKTACHROME 400 Film (Daylight) may be rated at ISO 800 when push processed. Merely decrease suggested exposure in this column by one stop.

FILTERS

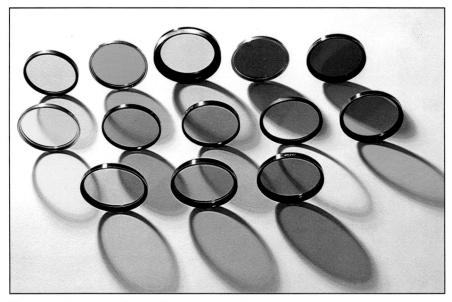

Photographers use filters for a variety of reasons. With colour film, filters can enhance or diminish effects of lighting colour. They can also correct the colour of light for film of a particular balance. (See "Film," page 134.) Haze and reflections can be diminished and saturation of colours can be increased with a polarizing filter. Deep colour filters primarily used for black-and-white film can be used for special effects with colour film. With black-andwhite film, filters can increase contrast, correct tonal relationships, reduce haze, and control reflections.

Many glass-mounted filters are available that will screw directly into the front of your lens.

Other filters are available as acetate squares. The squares fit into special frames.

The frames screw into the front of your lens, and can be adapted for a number of lens sizes.

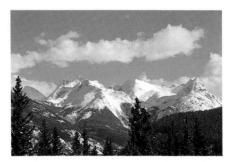

Without polarizer

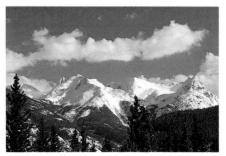

With polarizer

COLOUR FILM

Polarizer The polarizing filter reduces reflections from airborne moisture in the sky (haze) and from non-metallic sources. This means that sky, grass, and other subjects will show more accurate, richer colours. Aim your camera at a 90-degree angle (approximately) to the rays of light for maximum effect. You may also adjust the effect on most polarizing filters by turning the outer filter ring. A polarizing filter always requires a 1¹/₃-stop exposure increase. Adjust an automatic camera manually because the meter may not give correct exposure.

Polarizers will reduce reflections from nonmetallic surfaces such as glass and water. You can control how much reflection you eliminate by operating the adjusting ring on the filter. You may want to retain some sparkle in water scenes.

Without polarizer

With polarizer

Colour Correction Filters In the section on "Film", page 134, we discussed films with different colour balance. It's convenient if the film in your camera always matches the light where you're photographing. When it doesn't, you can attach the appropriate filter. See the table at right for possible film, light, and filter combinations. Notice also that the table gives exposure adjustment information. Since all filters block some of the light entering the camera, you must always give extra exposure. Operate vour camera manually if possible. Meter the scene without a filter attached, make the necessary adjustment, and then add the filter for your picture. (This may not be necessary with through-the-lens metering.) One note here-typical household lighting is tungsten 2900 K. There are also special lights for photography called photolamps 3200 K and 3400 K which require a different film and slightly different filters.

Table Instructions

Conversion filters change the colour quality of a light source to match the quality of the light for which a colour film is balanced. The table at right shows which filter to use with various film and light combinations. The table also shows how much additional exposure to give for the filters listed.

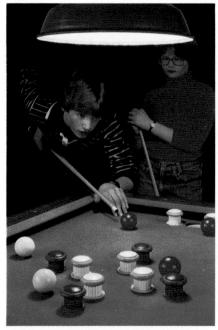

Tungsten light, daylight film, no filter. 168

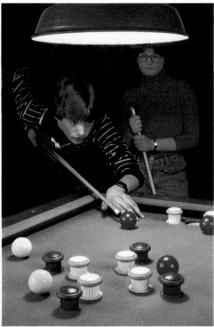

Add a No. 80A filter for correct colour.

KODAK Colour Films	Balanced for	Filter and <i>f</i> -Stop Change			
		Daylight	Photolamp (3400 K)	Tungsten (3200 K	
All KODACOLOR Films	Daylight,		*No. 80B + 1 ² / ₃ stops	*No. 80A + 2 stops	
KODACHROME 25 (Daylight)	Blue Flash, or Electronic Flash	No filter	No. 80B + 1 ² / ₃ stops	No. 80A + 2 stops	
KODACHROME 40-5070 (Type A)	Photolamps (3400 K)	No. 85 + ² / ₃ stop	No filter	No. 82A + 1/3 stop	
KODACHROME 64 (Daylight) and EKTACHROME 64 (Daylight)		No filter	No. 80B + 1 ^{2/3} stops	No. 80A + 2 stops	
KODACHROME 200 Professional (Daylight) EKTACHROME 200 (Daylight)	Daylight, Blue Flash, or Electronic Flash				
EKTACHROME 400 (Daylight)	<i>a</i>				
EKTACHROME 160 (Tungsten)	Tungsten (3200 K)	No. 85B + ² / ₃ stop	No. 81A + ¹ / ₃ stop	No filter	

Note: Increase exposure by the amount shown in the table. If your camera has a built-in exposure meter that can make a reading through a filter used over the lens, see your camera manual for instructions on exposure with filters.

*For critical use.

Daylight, tungsten film, no filter.

Add a No. 85B filter for correct colour.

Fluorescent light, daylight film, no filter.

Add a correction filter.

When exposing under fluorescent lighting, you'll get best results on colour negative film for prints. Use a correction filter on the lens to compensate for the greenish tint from fluorescent lights. These filters are supplied as 3-inch acetate squares. Glass averaging filters in screw-in mounts are also available. FLD on the filter denotes an averaging filter for fluorescent light with daylight film and FLB or FLT works with tungsten film and fluorescent light.

You can correct colour rendition with fluorescent light by using filters over the camera lens.

Left, photo was exposed under fluorescent lighting using daylight-balanced film without a correction filter. Right, photo shows the results with a correction filter.

Open shade, no filter.

Add a No. 81A filter.

There are filters that can warm or cool your colour picture slightly. Intended for advanced or professional use to get precise matches of film and lighting, they can be very handy for a subject in the blue light of open shade or the fiery light of sunset.

Sunset, no filter.

Add a No. 82A filter.

Creative Colours The filters used for black-andwhite photography come in a wealth of rich hues. Sometimes one of these can make a brilliant addition to your colour pictures. Naturally, blue filters make your pictures blue, and red filters make them red. Exposure is a matter of personal prefer-

Yellow filter

Orange filter

172

ence. Normally it's wise to increase the exposure slightly, but not as much as recommended for correct exposure with that filter and black-and-white film. Experiment a little to see how you like the effects best.

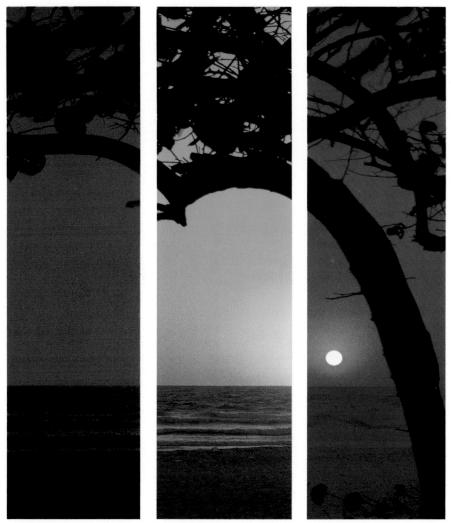

Red filter

Green filter

Deep blue filter

BLACK-AND-WHITE FILM

Black-and-white film records all colours in many tones of grey—from black through countless greys to white. Subjects that appear nearly white in prints have received a great deal of exposure; dark subjects not nearly as much. Filters transmit their own colour of light and subtract others, depending on their colour and density. A red flower photographed through a red filter will be nearly white, and the green leaves very dark grey.

Exposure Filters for black-and-white film require exposure compensation. See the table at right for filter and exposure recommendations.

Table Instructions

The table at right shows typical uses for filters with black-and-white film. To apply the exposure information, meter the scene without a filter, make the necessary exposure change, attach the filter, and take the picture.

Colour film

Black-and-white film, no filter

Black-and-white film, No. 25 red filter

Black-and-white film, No. 25 red filter and polarizer

Black-and-white film, No. 8 yellow filter

Filters can help bring out striking contrasts in blackand-white landscape photos. A No. 8 yellow filter gives the scene a tonal rendition similar to the colour version. A red or polarizing filter will heighten the contrast. Adding the red filter to the polarizer makes the scene even more dramatic.

Subject	Effect Desired	Suggested Filter	Increase Exposure by
Blue Sky	Natural	No. 8 Yellow	1 stop
	Darkened	Darkened No. 15 Deep Yellow	
	Spectacular No. 25 Red		3 stops
	Almost black	nost black No. 29 Deep Red	
	Night effect	No. 25 Red, plus polarizing screen	4½ stops
Marine Scenes When Sky Is Blue	Natural	No. 8 Yellow	1 stop
	Water dark	No. 15 Deep Yellow	1¼ stops
Sunsets	Natural	None or No. 8 Yellow	l stop
	Increased brilliance	No. 15 Deep Yellow or No. 25 Red	1 ¹ / ₃ or 3 stops
Distant Landscapes	Addition of haze for atmospheric effects	No. 47 Blue	2½ stops
	Very slight addition of haze	None	None
	Natural	No. 8 Yellow	l stop
	Haze reduction	No. 15 Deep Yellow	1¼ stops
	Greater haze reduction	No. 25 Red or No. 29 Deep Red	3 or 4 stops
Nearby Foliage	Natural	No. 8 Yellow or No. 11 Yellowish-Green	1 or 2 stops
	Light	No. 58 Green	2 ² / ₃ stops
Outdoor Portraits Against Sky	Natural	No. 11 Yellowish-Green No. 8 Yellow, or polarizing screen	2,1, or 1¼ stops
Flowers–Blossoms and Foliage	Natural	No. 8 Yellow or No. 11 Yellowish-Green	1 or 2 stops
Red, "Bronze," Orange and Similar Colours	Lighter to show detail	No. 25 Red	3 stops
Dark Blue, Purple, and Similar Colours	Lighter to show detail	None or No. 47 Blue	None or 2 ³ / ₃ stops
Foliage Plants	Lighter to show detail	No. 58 Green	2 ² / ₃ stops
Architectural Stone, Wood, Fabrics, Sand, Snow, etc. When Sunlit and Under Blue Sky	Natural	No. 8 Yellow	1 stop
	Enhanced texture rendering	No. 15 Deep Yellow or No. 25 Red	1 ¹ / ₃ or 3 stops
Interiors in Tungsten Light	Natural	No. 11 Yellowish-Green	2 stops

Contrast and Separation One of the main uses for filters in black-and-white photography is to separate subjects of different colours into strikingly different tones. Black-and-white film may see the red tones and the blue tones as nearly equal. A red filter will make the red tones white and the blue tones dark. A blue filter, however, will make the blue tones lighter and the reds dark. See the examples at right.

Colour correction Black-and-white film is affected by different qualities of light. Tungsten light is much redder than sunlight. A yellow-green filter can help the film render the correct tonal relationships in a scene lighted by tungsten light.

Polarizer A polarizing filter will also help reduce haze and reflection in black-and-white pictures while increasing contrast. The guidelines for handling and exposure adjustment are the same as for colour film. (See page 167.) Use colour filters to separate tones in black-and-white pictures. In the comparison at right, note the different values given to the red and blue areas by the red and blue filters.

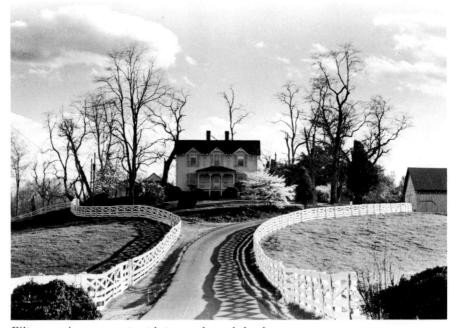

Filters can increase contrast between sky and clouds.

Black-and-white film, no filter

DEFORISRS

Black-and-white film, red filter

Black-and-white film, blue filter

LENSES

Single-lens-reflex cameras typically are sold with a normal lens which sees perspective and image size about the same as your naked eye. It is probably a fast lens with an f/2.8 or larger maximum aperture. The normal lens is designed for the kind of general picture-taking people do at home, on holiday, and at special events. What about other lenses?

TELEPHOTO LENSES

Telephoto lenses make subjects look bigger and they show less of the scene than a normal lens would. The magnification alters perspective by compressing distance relationships and consequently decreases depth of field. The strength of a telephoto lens is determined by its focal length—an optical measurement. The normal lens on a 35 mm camera is roughly 50 mm long. A 100 mm lens will give 2X magnification and a 200 mm lens 4X magnification.

Portrait photographers prefer a moderate telephoto lens (75 to 135 mm with a 35 mm camera) for a large image at a comfortable distance from the subject. The altered perspective gives a pleasing

Telephoto lens

LENSES

view of the subject's features and the shallow depth of field makes it easy to blur the background at large apertures. Strong telephoto lenses—200 mm and more—can help you get closer to sports, wildlife, and other distant subjects.

Camera movement is also magnified by telephoto lenses. Use a fast shutter speed (at least the reciprocal of the focal length, i.e., 1/250 second for a 200 mm lens) or give the camera solid support with a tripod to get sharp pictures.

WIDE-ANGLE LENSES

Wide-angle lenses see more of a scene than normal or telephoto lenses and subjects will be correspondingly smaller. Compared with a normal focal length lens, the distance between near and far objects and the depth of field are extended with a wide-angle lens when the subject distance remains the same.

Situations such as narrow streets and building

500 mm telephoto lens

100 mm telephoto lens

200 mm telephoto lens

50 mm normal lens

interiors demand wide-angle lenses. But be careful with people. The perspective can be grotesque with close subjects.

Moderate wide-angles-28 to 35 mm-are so useful that many photographers consider them normal lenses. Very wide-angle lenses-18 to 25 mm-are more extreme and are generally used for special applications or to amplify distortion.

ZOOM LENSES

Zoom lenses offer an economical and convenient alternative to a large assortment of single-focallength lenses. They come in a wide variety of focal-length ranges and give excellent results. For travelling a typical zoom lens choice would be a 28 to 85 mm zoom and an 80 to 200 mm zoom. These two lenses plus your fast normal lens for dim light could capture nearly any subject, yet occupy little space in your luggage.

35 mm wide-angle lens

28 mm wide-angle lens

24 mm wide-angle lens

16 mm wide-angle lens

CLOSE-UPS

With many cameras, you can usually find a way to isolate small subjects such as a single big flower or a tidy group of lesser blossoms. The easiest way is with an accessory called a close-up lens, which allows you to get closer than the minimum focusing distance for your camera. More advanced cameras have a threaded connector at the end of the lens where you can screw in close-up lenses or filters. Less advanced cameras might require you to tape a close-up lens over the camera lens.

Close-up lenses come graded in dioptres-typically +1, +2, and +3. The higher the number, the closer you can get, and the bigger your image will be. If you have a camera that has a viewfinder separate from the lens, it might be best to use only one close-up lens, a +2 for instance, so that you get completely familiar with how it works. (As you'll see later, close-up lenses require a little measuring and calculation for accurate results.) A single-lensreflex camera, however, shows you in the viewfinder almost exactly what will be on the film, so you can use any close-up lens, or even a combination of close-up lenses for the best treatment of your subject.

The viewfinder for any rangefinder camera is adjusted to give you accurate framing (you get what you see) from the minimum focusing distance to infinity. At the closer distances you'll use with a close-up lens, the viewfinder will not show exactly what the film will record. And, since depth of field is so shallow at close focusing distances, you'll want the camera lens to be at the precise distance recommended by the close-up lens instruction sheet or in the table on page 185. To aim your camera from the correct distance, attach a string to the camera with a knot tied at the recommended distance. Extend the string until the knot just touches the subject. Then you're at the right distance. When you hold the string out, make sure the camera lens is pointed directly at the subject. Then drop the string and snap the picture. With practice, this becomes a simple and effective way to make close-ups.

HOW TO TAKE GOOD PICTURES

Almost as easy, and much more accurate is a lightweight cardboard measuring device. Cut to the recommended distance, the board should have a lengthwise line at centre that you line up from camera lens to subject. The board should be only as wide as the long dimension of the field of view for that close-up lens. That way, you'll know how much of the subject will be included in the picture. Make sure the camera isn't tilted up to down, remove the cardboard, and take your picture.

Cardboard measuring device

Attaching +1 close-up lens

Shown below is information you'll want to use for taking close-up pictures with a rangefinder camera. The left column shows different close-up lenses and lens combinations at various camera lens focus settings. The next column gives subject distances for you to measure. The columns on the right give the field size (subject area) for the combinations shown at left. Just remember to measure the distance carefully from the subject to the film plane (which corresponds approximately to the rear upper edge of the camera top). Aim the camera lens directly at the subject. If you make a cardboard measuring device like the one illustrated, do a little additional measuring before you cut the length; for holding in front of the lens, it needs to be shorter than the subject distance in the table by an amount equal to the distance from lens to film plane.

Incidentally, close-up lenses require no exposure compensation.

	Close-Up Lens Data					
Close-up Lens and		Subject	Approximate Field Size (centimetres)			
Foc Sett (met	ng	Distance (centimetres)	45 mm Lens on a 35 mm Camera	50 mm Lens on a 35 mm Camera		
	Inf	96	42 x 63	40 x 60		
	6	84	$38 \ge 58$	$34 \ge 52$		
+1	3	75	$33 \ge 50$	30 x 45		
	2	68	$30 \ge 45$	$28 \ge 42$		
	1	54	23 x 34	20 x 30		
	Inf	50	20 x 30	19 x 29		
	6	46	19 x 29	$18 \ge 27$		
+2	3	44	$18 \ge 27$	$17 \ge 25$		
	2	42	$17 \ge 25$	15 x 23		
	1	37	$14 \ge 21$	$13 \ge 20$		
	Inf	37	14 x 21	13 x 20		
+1	6	35	$13 \ge 20$	13 x 19		
plus	$ \begin{array}{c} 3 \\ 2 \\ 1 \end{array} $	34	13 x 19	$12 \ge 18$		
+2	2	33	12 x 18	11 x 16		
τZ	1	30	11 x 16	$10 \ge 15$		

HOW TO TAKE GOOD PICTURES

CAMERA CARE

Although a precision instrument, your camera is designed for hard use. It does deserve whatever care you can provide. Here are some guidelines:

- 1. Protect your camera from dirt and bumps with an ever-ready case.
- 2. Keep the inside clean by using a soft brush or air syringe at film-change time. You can also use canned compressed air, but follow instructions on the can or in your camera instruction manual carefully. Misuse could damage your camera. Also, aim the air stream precisely—it's possible to blow debris *into* the camera.
- 3. Keep the lens protected from dirt and fingerprints with a lens cap.
- 4. Clean the lens by first brushing or blowing off surface debris. Then use photographic lens tissue (not the kind for spectacles) and a drop or two of lens cleaning fluid to wipe off smudges.
- 5. Protect your camera from water-particularly

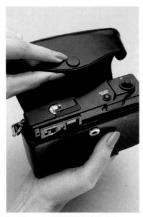

1. Use a camera case.

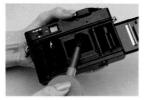

2. Keep the camera clean. 186

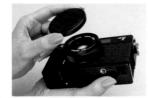

3. Protect the lens.

4. Clean the lens.

5. Shield your camera.

6. Change the batteries.

7. Remove for storing.

salt spray—in a plastic bag or zippered camera case. Attach a UV filter to the lens to protect the vulnerable glass surface from water, dust, sand, and other airborne particles.

- 6. Change the batteries for meter, flash, and motorized film-advance according to the camera instruction manual.
- 7. Remove the batteries when storing your camera. If left for long periods, they could corrode the camera electrical contacts.
- 8. Allow a camera used in cold air to warm up gradually when brought indoors to help prevent condensation. Keep the lens cap attached.
- 9. Do not leave your camera in a very warm place, such as the glove compartment of your car. Avoid damp basements, too.
- 10. At the first sign of malfunction, have your camera checked over by a competent repair technician.

8. Allow slow warm-up.

9. Avoid extreme heat.

10. Check problems with a technician.

PHOTO CREDITS

The following list of photographer credits does not include the dozens of comparison, equipment, and technique photos made by Kodak staff photographers and employees Donald Buck, Neil Montanus, Marty Czamanske, and Michele Hallen Infantino. Freelance photographers Mark Hobsen, Tom Beelmann, and Jerry Antos made significant contributions.

Much appreciation is due Kodak Limited who contributed comparison and technique photos taken in Great Britain and in Europe under the supervision of Mr. Jack Oakley.

Many of the illustrations came from the files of the Kodak International Newspaper Snapshot Contest and the Scholastic Photo Contest. Although a proportional number of the entrants are accomplished amateur photographers, a larger number are snapshooters in homes just like yours. The joy and spontaneity of these images should be inspiring and encouraging to picture-takers everywhere.

0 0	1		
Cover	Randy Wegener	67	Judith Ferre, top left
Page 2	Phoebe Dunn (all)		Cynthia Maggs, top center
5	Derek Doeffinger		Larry Daniels, center
	Marty Taylor		Dennis Hallinan, top right
	Derek Doeffinger		K. Ando, bottom
7	Neil Montanus	68	Victoria Belch
8	Don Maggio	69	Neil Montanus
9	Gary Jewell	70-71	Norman Kerr
11	Norman Kerr, top	72-73	Cole Weston
	Courtesy Kodak Ltd., bottom	74	Clarence Halbrook, top
12	Neil Montanus, bottom		Gary Michaelson, left
13	Lee Howick		Kent Gavin Bailey, right
14	Mary Warren, bottom	75	Norman Kerr, top
15	Marty Taylor (all)		Jim McCauley, bottom
16	Tony Boccaccio	76	Ray Atkeson, top
17	Bob Clemens		DeAnne Parajewick, bottom
18 - 27	Michele Hallen Infantino	76-77	David Muench, top
28	Michele Hallen Infantino		Robert Walch, bottom
29	Michele Hallen Infantino	77	David Muench, bottom right
32 - 40	Michele Hallen Infantino	78	Paul Tjossen, top
46	Jean Lengellé, top		F. Wendell Huntington, bottom
48,49	Michele Hallen Infantino	79	H. Wendler, top left
50-51	B. Cripe, Jr.		Dale Newbauer, right
51	Peter Gales, top left	80	Neil Montanus, top
	Milan Hnidka, Jr., top center		Dennis Burns, bottom
	Andrew Schreffler, top right	81	Bob Harris, top left
52	Peter Gales, bottom left		William Simpson, top right
	Bob Clemens, top right		Y. Shirakawa, bottom right
	Lanny Carnes, bottom right	82-83	Courtesy Kodak Ltd. (all)
53	Bob Clemens, top left	84	Jack Novak
	Bob Clemens, bottom left	85	Jim Dennis
54	Sam Campanaro	86	Norman Kerr, top left and bottom
56	N. R. Grover, top		Peter Gales, top right
	Derek Doeffinger, bottom	87	Don Henley, top left
57	Courtesy Kodak Ltd., bottom left		Neil Montanus, top center and top right
	Janice Penley Keene, bottom right		Richard Arentz, bottom left
62	Tom McCarthy		Judith Hawkins, bottom right
63	Courtesy Kodak-Pathé	88	Gary Matuszak, top
64	Tom Masato Hasegawa		Norman Kerr, bottom
65	James Kendal	88-89	Neil Montanus, top
66	Rolando Saenz, top left		Norman Kerr, bottom
	Frank Phillips, top right	90	Loren Banninger, top
	Margaret Peterson, bottom		Tom McCarthy, bottom left

Art Griffin, bottom right 91 J. P. Marchand, top Robert Allen, bottom 92 Patricia Bordman, top 92 - 93Luis Marrero Thomas Wienand, top 93 Helmar Gehrisch, center right Morton Beebe, bottom left Neil Montanus, bottom right 94 Norman Kerr, bottom 94-95 Keith Boas, top 95 Bill Ratcliffe, top right Josef Muench, bottom left H. F. Mayer, bottom right 96-97 Norman Kerr 98 Bob Clemens, top left Steve Kelly, top right Bob Harris, bottom left 98 - 99Marty Taylor Norman Kerr, top left 99 Rose Rengers, center left 100 Gabriel Vaillancourt 101 Charles Rogers, top Kevin Keegan, bottom 102 Doris Gehrig Barker 102 - 103Neil Montanus Michael Handy, top 104 105 Robert Padrilla, top John Menihan, bottom 106 John Phelps, top left Otto Done, bottom left 106 - 107Mary Lorenz 107Keith Boas, bottom left John Olsen, bottom right 108 - 109Warren Wind 110Neil Montanus, top Elyse Lewin, center left 110 - 111Bruce Pierce 111 David Stelzer, top left Marty Taylor, right 119 Norman Kerr 127 Marty Czamanske 133 Steve Cangialosi, top left

John Vaeth, top right

Michele Hallen Infantino, bottom

134 Courtesy Kodak Ltd. 135 Michele Hallen Infantino 136 John Brink 137 Keith Boas Frederick Luhman, left 140 Michael Funk, right 141 Don Maggio, left Bijov Bhuvan, right 144 Courtesy Kodak Ltd. 145 David Hoops 146 Neil Montanus, top Lee Bales, Ir., bottom 147 Donald Lamb Marty Taylor, top 148 Neil Montanus, center 150 Neil Montanus, left Bermuda Tourist Bureau, right 151 Janet Meharg, top Catherine Johanson, bottom 152 Robert Brink 153 Courtesy Kodak Ltd., top 160 - 161Henry Katz 162 Courtesy Kodak Ltd., top Carmina de Rodriguez, bottom 164 Dan Kaplan 170 Tom Beelmann Iames Thompson 176 179David Parsons 180 - 181Robert Llewellvn James Dieffenwierth 182 - 183184 Neil Montanus, top left Don Maggio, center Cammie Warner, top right Gail Atchison, bottom left 184 - 185Helen Ittner 185 Barbara Dick, top Back Cover Neil Montanus, top left Willinger, top center Tom Beelmann, top right Norman Kerr, center left H. F. Mayer, center center B. Cripe, Jr., center right James Hamric, Jr., bottom left David Robertson, bottom center Alan Brebner, bottom right

INDEX

Action, 101, 102, 141, 160, 161 Aerial perspective, 80 Albums, 23, 71, 112, 113, 115 Aperture, 9, 35, 36, 37, 136, 138, 141, 144, 152, 156, 157 aperture/distance range mode, 42, 155 aperture preferred, 35 aperture ring, 35, 36, 128, 130, 159 large aperture, 55, 58, 106, 138, 141, 144, 145, 163 maximum aperture, 162, 178, 180 small aperture, 55, 63, 64, 144, 145 Automatic camera, 17-21, 32-34, 138, 142, 143 Automatic flash, 21, 27, 42, 154. 155 Automatic mode, 61 Bad weather, 108 Background, 10, 46, 55, 80, 90, 94, 99, 123 Balance, 78 Batteries disposable batteries, 40, 43, 121, 122, 123, 131, 157, 186-187 rechargeable batteries, 43, 157 Black-and-white film, 48, 132, 166, 174 - 177Blurred action, 105, 141 Bounce surface, 61, 159 Buildings, 96-98 Bulbs, tungsten, 49, 57, 59 Candid pictures, 62, 71 Camera angle, 53, 64, 72, 74, 86, 167 Camera care, 120, 186-187 Camera controls, 128-131 Camera movement, 11, 120, 180 Camera support, 46, 120, 163 Camera-to-subject distance, 43, 144 Capacitor, 157 Cartridge-loading camera, 16, 28 - 30110-size cartridge, 28-30, 48 126-size cartridge, 28-30, 48 Centring the subject, 12 Clean lens, 186 Close-ups, 25, 28, 94, 99, 182-185 Cold weather, 108, 135, 187 Collectables, 99 Colour, 72, 77, 78 colour balance, 59, 134, 166, 168 - 169colour correction, 59, 108, 134, 168-169, 176 colour prints, 48, 112-115, 118, 132 colour slides, 48, 116-117, 118, 132 Contrast and separation, 176 Common problems, 120 Composition, 78, 102 informal balance, 78 symmetrical design, 78 Copyprints, 23, 114 Daylight film, 49, 134, 164, 168-171 Depth of field, 55, 64, 141, 144-145, 163, 180-181 Depth of field scale, 144 Diopters, 182 Direct sunlight, 51, 53, 148-149 190

Direction of light backlighting, 14, 51, 64, 81, 121, 142.146 frontlighting, 14, 51, 81, 146 reflected light, 51, 148 sidelighting, 14, 51, 81, 121, 142, 146, 148 Direction of movement, 104 Disc camera, 16, 24-28 Distortion, 181 Enlargements, 113, 114, 118, 132 Exposure, 143 exposure with automatic and semi-automatic cameras, 31-40, 136 - 143exposure control, manual, 33. 38-39, 142 exposure meters, 36, 58-59, 135, 142, 163, 164 overexposure, 9, 121 underexposure, 9, 121 Fast lens, 178 Film black-and-white, 48, 132, 166, 174 - 177expiration date, 49, 124, 135 colour prints, 48, 112-115, 118, 132 colour slides, 48, 116-117, 118, 132 Film-advance lever, 128, 129 Film-advance release button, 131 Film-frame counter, 38, 128, 129 Film-instructions, 135 Film sensitivity, 48, 136 Film size, 48, 132 Film speed, 36-37, 42, 43, 48, 58, 63, 64, 106, 110, 111, 121, 122, 133, 136, 141, 153-157, 162 Film-speed indicator, 142 Film-speed selector dial, 36, 128, 129.131 Film winding mechanism, 125 Filters CC (Colour Compensating) filters, 59 170 - 171CC30M filter, 59, 170 colour correcting filters, 59, 108, 124.134.168-169.176 conversion filters, 168-169 polarizing filters, 166, 176 Flash bounce flash, 61, 159 dedicated, 42, 60, 155, 158, 159, 160 disposable flash devices, 29, 30, 31 electronic flash, 17, 21, 22, 27, 40, 60, 128, 131, 154, 155 fill-in flash, 22, 52, 53, 55, 148, 160, 161 flash calculator, 43, 60, 61, 122, 156-157 flash-cord socket, 41, 128, 154 flash-distance range, 11, 21, 28, 43, 91, 153, 154 flash exposure, 42, 154-155 flash extender, 153 flash mode, 42, 155 flash off camera, 158 flipflash, 60, 154 hot shoe, 41, 128-129, 154

magicubes, 154 manual flash exposure, 42-43, 156 pop-up flash, 40, 128, 129, 131 sensor automatic electronic flash units, 42, 60, 61, 155, 158, 159, 160 Flash-to-subject distance range, 11, 28, 42, 43, 60, 61, 91, 122, 153, 154, 158 FLD, 170 Flowers and plants, 94 f-number, 138, 140 f-stop, 157 Fluorescent light, 57, 59, 170-171 Focal length, 178-181 Focal plane shutter, 154 Focus, 20, 36, 40, 45, 120 automatic focusing, 31, 32, 40, 45 focusing ring, 40, 45, 128, 130 preset focus, 101, 105, 144 Fogging, 125 Foreground, 10, 46, 55, 79, 80, 123 Framing, 79 Greeting cards, 114 Guide numbers, 157 Handheld meter, 36, 59, 142 Haze, 72, 80, 166, 167, 175, 176 Heat and humidity, 49, 115, 124, 135, 189 Holding the camera steady, 11, 44, 163 Home décor, 113 Horizons, 46, 75, 76 Horizontal and vertical pictures, 12, 72, 76, 97 "Hot shoe," 41, 154 Instruction manual, 12, 16, 120, 123, 128, 142 ISO, 9, 17, 37, 48, 133, 156-157 Keeping the lens clear, 44, 124 Landscapes, 72, 79, 174 Leaf shutter, 154 Lens, 128, 130, 178-181 close-up lenses, 94, 99, 182, 184-185 dirty lens, 120 lens cap, 121, 186, 187 lens cleaning, 186, 187 lens distance scale, 43, 45, 60, 144, 156 normal lens, 178 telephoto lenses, 63, 178, 180 wide-angle lenses, 63, 181 zoom lenses, 181 Lighting, 146-151 angles, 146-147 artificial light, 57 conditions, 36-37, 59 diffused sunlight, 148 direct light, 51, 53 existing light, 57, 58, 70, 92, 105, 162-165 indirect light, 69 intensity of light, 51, 149 shade, 53, 69, 148 seasons, 150 Lines. 78, 80 Manual cameras, 36, 88, 142, 156 Manual flash, 43, 156

Manual override of automatic exposure, 142 Negatives, 114, 115, 132 Nickel cadmium cells, 157 Night, 106, 165 **Objets d'art**, 99 Overexposed foreground, 123, 153 Panning, 101, 102, 104, 105 PC cord, 41, 61, 154, 156, 158 Peak of action, 102 People, 50-71 children, 64, 92 elderly people, 69 indoors, 57-61 natural activity, 13, 69 natural expressions, 55, 69, 108 outdoors, 51-55 Perspective, 79, 84, 91, 178, 180, 182 Pets, 90-91 Photo albums, 23, 71, 112, 115 Photo inventory, 119 Photo reports, 118 Photofinisher, 113, 114 Photographic lens tissue, 186 Photographic lights, photolamps, 49, 57, 58, 99, 168, 169 Planes, 80 Pocket cameras, 28-30 Polarizer, 166, 167, 174, 176 Pop-up flash, 40, 128, 129, 131 Portraits, 69, 150, 180 Processing services, 28, 114

Push processing, 163 Rain. 108 Ready case, 186 Ready light, 40, 60, 122, 154 Recycle times, 43, 122, 154 Reflections, 123, 152, 166, 167, 176 Red reflections, 122, 152 Reflectors, 51, 57, 58, 99, 148-149 Rewind knob, 128, 129 Rewind lever, 22, 39, 129 Rule of thirds, 78 Scale, 79 Scene brightness, 136 Seasons, 94, 150 Self-timer, 47, 128, 131 Self-quenching automatic, 42, 60 Sensor, 42, 61, 155, 159 Shapes, 72, 77 Shoe, 41, 154 Shutter release, 11, 44, 47, 120, 128, 129, 163 Shutter speed, 9, 32-36, 41, 58, 64, 92, 101-105, 106, 120, 123-129, 134, 135-143, 157 Shutter-speed preferred, 34 Shutter-speed selector dial, 128, 129, 138 Single-lens reflex, 31, 32, 41, 45, 178, 182 Slide shows, 116-118 Snapshot cameras, 63, 154 Snow, 37, 108, 142, 150 Sports, 105

Storing pictures and negatives, 115 Static electricity, 135 Symmetrical design, 78 Synchronization setting, 41, 156 Telephoto lenses, 28, 63, 178, 180 Telling a story, 88, 116-117 35 mm camera, 16, 17-23, 31-43, 126-131, 132, 154 Through-the-lens metering, 168 Time of day, 82, 94, 98, 111, 148-149 Travel, 84-89 Tripod, 46, 105, 163, 179 Tungsten film, 124, 134, 164 Viewfinder, 20, 36, 46, 128, 129, 131 Water, 72, 108, 167 Weather conditions cold, 108, 135, 187 haze, 37, 72, 80, 166, 167, 175, 176 heat and humidity, 49, 115, 124, 135, 187 overcast sky, 37, 52-53, 64, 69, 108, 110, 148 rain, 108 snow, 37, 108, 142, 150 Weddings, 70-71 Wide-angle lens, 63, 181 X-rays, 89, 125 Zoom lenses, 181 Zoos, 92

Kodak, VR, Instamatic, Kodacolor, Ektachrome, and Kodachrome are trademarks.